Leonardo da Vinci Drawings
Masterpieces of Art

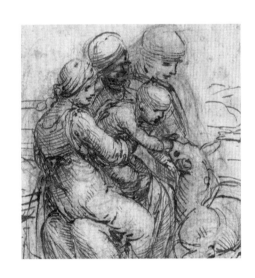

Publisher's Note

Leonardo da Vinci wrote in Italian, using a technique called 'mirrored writing' that would start at the right side of the page and continue to the left. Many of the images from his notebooks and studies included in this book showcase this writing style.

Publisher and Creative Director: Nick Wells
Project Editor: Polly Prior
Picture Research: Josie Mitchell and Gillian Whitaker
Art Director: Mike Spender
Copy Editor: Ramona Lamport
Proofreader: Amanda Crook
Indexer: Helen Snaith

FLAME TREE PUBLISHING

6 Melbray Mews,
Fulham, London SW6 3NS
United Kingdom

www.flametreepublishing.com

First published 2015

15 17 19 18 16
1 3 5 7 9 10 8 6 4 2

© 2015 Flame Tree Publishing Ltd

Image credits: Courtesy of **Bridgeman Images** and the following: Private Collection/The Stapleton Collection 4, 20 (b), 26 (r), 109, 118, 120; Royal Collection Trust © Her Majesty Queen Elizabeth II, 2015 6 (t, b), 7, 8, 9, 13, 14, 17, 18, 19 (t), 22, 23, 26 (l), 27, 34, 35, 36, 39, 40, 41, 44, 46, 48, 51, 52, 54, 55, 57, 60, 61, 62, 63, 64, 65, 67, 68, 70, 73, 74, 75, 77, 79, 80, 81, 82, 83, 100, 105, 107, 108, 110, 111, 112, 114, 115, 125, 123; Biblioteca Reale, Turin, Italy/Alinari 10, 33; Galleria degli Uffizi, Florence, Italy 11, 15, 31, 104; Institut de France, Paris, France 12, 106; British Museum, London, UK 16, 32; Bibliotheque de l'Institut de France, Paris, France 19 (b), 98; Galleria dell' Accademia, Venice, Italy and the following contributors: 20 (t), 43, 66; Cameraphoto Arte Venezia 37, 53; Mondadori Portfolio/Electa/Osvaldo Böhm 38; National Gallery, London 21, 42; De Agostini Picture Library and the following contributors: 24 (r), 30, 69, 99; Metis e Mida Informatica/Veneranda Biblioteca Ambrosiana 24 (l), 25, 86, 87, 88, 89, 90, 91, 92, 93, 94, 95, 96, 97, 119, 121, 122; R. Bardazzi 76, 78; Palazzo Reale, Turin, Italy/Alinari 47; Universal History Archive/UIG 50; Biblioteca Ambrosiana, Milan, Italy/Alinari 56; © Tarker 71, 124; © Christie's Images 116, 117.

ISBN: 978-1-78361-358-8

Printed in China I Created, Developed & Produced in the United Kingdom

Leonardo da Vinci
Drawings
Masterpieces of Art

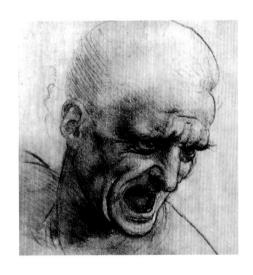

Susan Grange

**FLAME TREE
PUBLISHING**

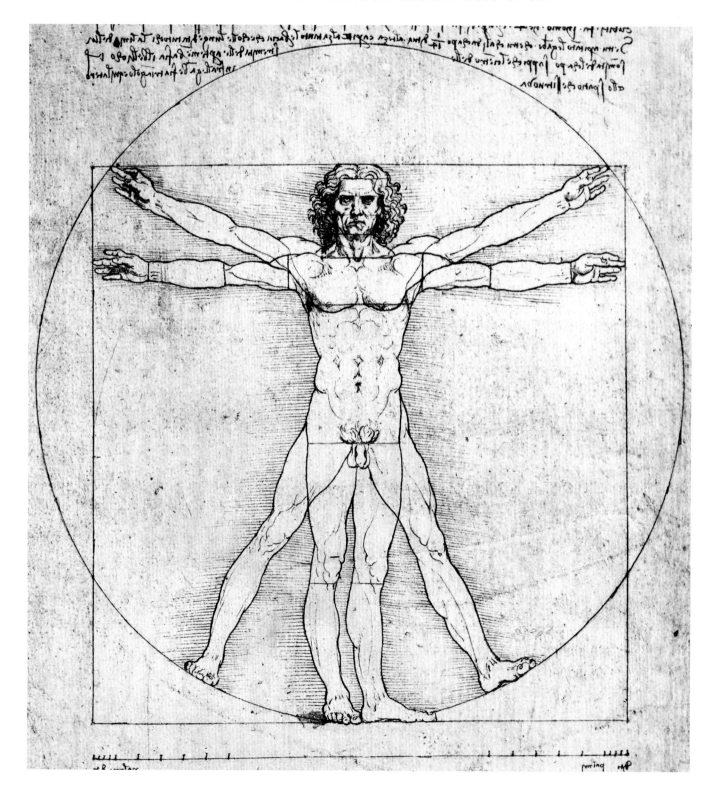

Contents

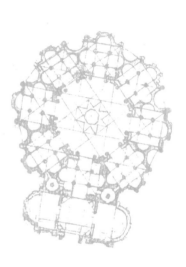

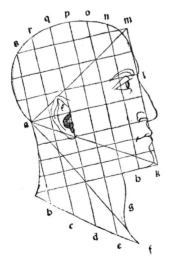

Leonardo da Vinci: The Universal Man

 ainter, draughtsman, architect, military engineer, musician, scientific researcher, designer: Leonardo da Vinci (1452–1519) was all these and more. Revered as a universal genius, Leonardo has come to represent the archetypal Renaissance man, a polymath and scientific visionary exploring ideas and designing inventions that were hundreds of years ahead of their time. Although he painted two of the most famous paintings in the world, the _Mona Lisa_ (1517) and _The Last Supper_ (1498), it is through his drawings that we can find the most direct access to his genius.

There are few surviving paintings that are attributed or partly attributed to Leonardo but around 6,000 pages of his drawings survive, thought to be only around half of his output. The drawings express ideas, statements, plans, suggestions and projects. They allowed Leonardo to explore a wide range of subject matter unhampered by the necessity of producing a complete and finished work. They gave him freedom in his search for knowledge and facilitated the flow of his enquiring spirit.

Beginnings

Leonardo was born on 15 April 1452 in a small Tuscan hamlet near to the town of Vinci, 29 miles (46 km) from Florence. Vinci was an ancient settlement, founded by the Etruscans and later occupied by the Romans. A sixteenth-century map shows the medieval walls, a castle, a town hall and the church of Santa Croce. The name Vinci derives from the word 'rushes', which grew by the local stream and which in that area of Tuscany were woven and braided. Leonardo took the symbol of the interwoven rushes, _vinci,_ as his own and he often drew elaborate knots in his notebooks and introduced the emblem into some of his works. For him it became something of a symbol representing an intellectual and visual puzzle.

His father, Piero da Vinci (1426–1504), was 25 years old at the time of Leonardo's birth, and for at least four years had been a notary in Pisa and in Florence. Leonardo's mother was Caterina, a peasant girl who was not married to Piero, and therefore Leonardo was an illegitimate child. A few years after Leonardo's birth his father married a young girl from a wealthy Florentine family who died in childbirth in 1464. Piero

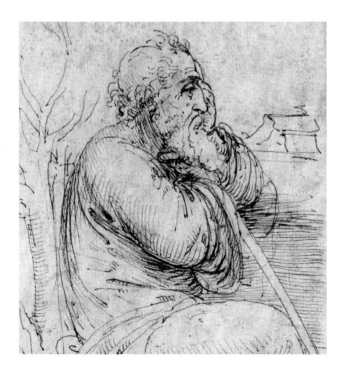

went on to marry three more times and created a wide circle of half-brothers and sisters for Leonardo. Caterina also went on to marry shortly after Leonardo's birth and had five more children.

Family Life and Education

Although illegitimate, Leonardo's birth was celebrated by neighbours and friends; at his baptism he had five godmothers and godfathers all from the town. Warmly welcomed into his father's family circle he was clearly a much-loved child. By the age of five he is recorded as living in the house of his grandfather, Antonio da Vinci. Antonio had not followed the family practice of working as a notary but owned and farmed land in the district, an area of vineyards and olive groves. Leonardo's uncle Francesco owned a mill nearby. Encouraged by his grandfather and uncle, the young Leonardo grew up in an environment where he studied nature, the earth, the winds, the streams and rivers, the flowers and trees, imbibing the atmosphere and the elements of the landscape while at the same time encountering the wildlife of the area, which he could observe and study.

Leonardo was educated at home by tutors and from an early age his precocious intelligence and abilities were evident. Because of his illegitimate status it was unlikely that he would have been able to follow in the family tradition of becoming a notary, and this perhaps resulted in him having a less formal education than may have been the case otherwise. His interests were broad ranging and spanned the arts, the sciences, natural history and music; he learned to play the lyre and accompanied himself as he sang. It seems that Leonardo was always impatient to learn new things and would quickly move from one subject to another, often abandoning projects before they were finished and not submitting to the discipline of completing tasks. This has been put forward as a possible reason why he failed to complete so many projects and commissions in later life.

Artistic Influences

Leonardo's grandmother's family were also landowners and notaries but some family members were potters and producers of painted majolica. Their pottery in Carmignano, not far from Vinci, was linked

to one of the most productive centres of ceramic production of the fourteenth and fifteenth centuries. Leonardo was known to have visited the pottery when he was a child and his father inherited the family kiln. Vinci in the heart of Renaissance Tuscany had close dealings with nearby Pistoia where one of Leonardo's aunts lived. In its main church of Sant'Andrea the striking medieval bas-reliefs made by Giovanni Pisano (c. 1250–c. 1314) could be seen. The figures have animated expressions and movements including pointing fingers, a gesture which would become something of a symbol for Leonardo.

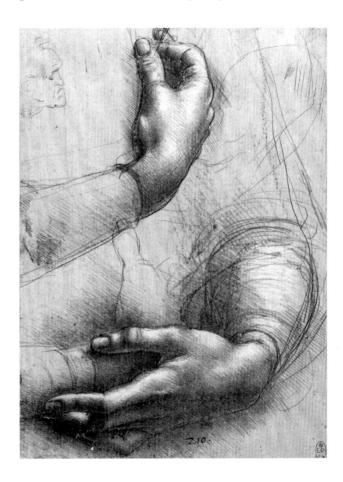

In the church of Sant'Antonio dei Frati del Tau he saw the anonymous fourteenth-century frescoes with dramatic flood scenes, another theme that was to recur in Leonardo's art. Also in Pistoia the renowned architect Michelozzo (1396–1472) was responsible for the design of the church of Santa Maria delle Grazie. The city of Empoli was close to Vinci

and in the later medieval period had been a centre of artistic activity. Here could be found paintings by Agnolo Gaddi (*c.* 1350–96), Lorenzo Monaco (*c.* 1370–*c.* 1425) and Masolino (*c.* 1383–*c.* 1447), and sculptures by Bernardo Rossellino (1409–64) and Mino da Fiesole (1429–84). In the church of Santa Croce in Vinci itself could be seen a painted wooden statue of Mary Magdalen from 1455 by an unknown artist, which echoed the famous work by Donatello (1386–1466).

Mirror Writing

Leonardo was left-handed and from an early age wrote from the right-hand side of the page to the left, perhaps a habit that, like other things to do with his education, was not corrected as a child; or perhaps it was possibly to avoid smudging the ink with his arm. It seems unlikely that this was done as a type of code. In his notebooks he would often fill in the right page first and then move to the left page. Geiorgio Vasari (1511–74), the artist and writer, included a description of the life and work of Leonardo in his book *Le Vite de' Piu Eccellenti Pittori, Scultori et Architetti (The Lives of the Most Eminent Painters, Sculptors and Architects).*

In it Vasari advises anyone who wishes to read Leonardo's writing to use a mirror. Leonardo did at times also use the normal conventions of handwriting when it was necessary that his intentions be clear. In later life he would usually dictate his official communications to an assistant. He also used his right hand to draw; so perhaps that ambidexterity gave him extra freedom and further developed his senses and mental abilities.

Early Character

Leonardo appears to have been a very personable child. Good-looking and developing into a handsome young man, Vasari tells us that Leonardo was physically strong. He was also of a kindly nature with a love of animals and all creatures. His attractive personality, and his beautiful singing and playing, were perhaps other reasons why he seems to have been indulged by his family and tutors. Vasari also relates that beauty, grace and talent were united in Leonardo who 'was so pleasing in conversation that he attracted to himself the hearts of men'. We know from later comments that Leonardo was careful how he dressed and always strove to present himself well.

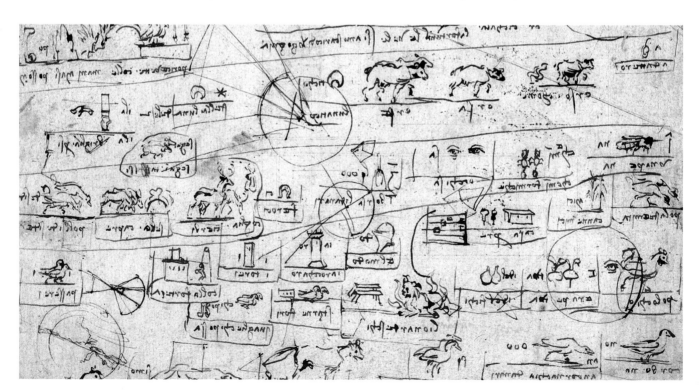

Artistic Talent

Vasari tells us that even though Leonardo as a child and youth was involved with many activities and interests, 'he never ceased drawing and working in relief, pursuits which suited his fancy more than any other'. This particular aptitude did not go unnoticed by his father, who by the time Leonardo was in his teens was working at the top of his profession as a notary in Florence at the Palagio del Podestà, the seat of the chief law officer. This placed him in an ideal setting to further his son's artistic career. Again according to Vasari: 'Piero one day took some of Leonardo's drawings along to Andrea del Verrocchio (who was a close friend of his). Andrea was amazed to see what extraordinary beginnings Leonardo had made and urged Piero that he should make him study the subject.' And so began Leonardo's apprenticeship in Verrocchio's workshop. The actual date when Leonardo joined the workshop is a matter of some discussion among historians but is thought to have been around 1468–69.

Verrocchio's Workshop

Verrocchio (c. 1436–88) was the ideal master for Leonardo to work with. He was not simply a painter; already he was famous in many forms of the creative arts. Vasari describes his accomplishments as a 'goldsmith, a master of perspective, a sculptor, a woodcarver, a painter and a musician'. The stimulating and comprehensive curriculum that he provided for his apprentices not only covered painting, architecture and sculpture but also provided a foundational training in botany, optics and music. He was also an astute businessman and contractor. The calibre of Verrocchio's apprentices at this time was of an amazingly high standard; some of the leading artists of the Renaissance trained with him, including Sandro Botticelli (1445–1510), Pietro Perugino (c. 1446–1524) and Domenico Ghirlandaio (1449–94), among others. Verrocchio produced a number of works that Leonardo would have been involved with during his time in the workshop. One such work was a bronze statue of the biblical hero David for Piero di Cosimo de Medici (1416–69); it has even been suggested that Leonardo himself may have been the model for this work.

Apprentices in the workshop would usually live together and work together, being taught how to prepare colour pigments, how to paint in oils and the techniques of fresco painting. They would work with Verrocchio on site, as well as in the workshop, and when they were considered advanced enough they would be given small sections of work to complete. Vasari gives us some detail of Leonardo's time in the workshop: 'He was an excellent geometrician, he not only worked in sculpture making, in his youth, in clay, some heads of women that are smiling, of which plaster casts are still taken, and likewise some heads of boys which appeared to have issued from the hand of a master.' These early models are unfortunately lost. Vasari goes on to tell us that Leonardo drew up plans for buildings and created designs for mills. He suggested plans to turn the Arno River into a canal and proposed the creation of engines powered by water. Clearly Verrochio challenged his most able pupil by the variety of tasks he assigned him and which it seems, under Verrocchio's discipline, Leonardo fulfilled.

Leonardo's Early Work

Exactly what Leonardo contributed to joint workshop collaborations has been the subject of controversy. We can be certain that he contributed to *The Annunciation* (c. 1470–75), as a preliminary drawing exists of the angel's arm. It is also thought that Leonardo added details of the landscape, which reveal his interest in geology; and tests on the

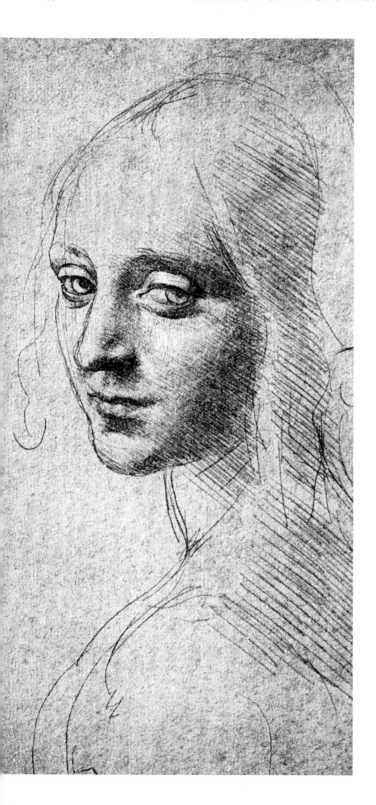

painting have revealed Leonardo-style *pentimenti* (alterations) to the underlying drawings of the angel's profile and the Virgin's head. Some art historians believe that he painted the whole work, perhaps as some sort of graduation study. It is also thought that Verrocchio's *Baptism of Christ* (*c.* 1470–72 and 1475–78) contains parts by Leonardo. Vasari tells us that the angel on the far left, with its delicate, ethereal features, who is turning towards Christ, is by Leonardo's hand. The effect of the refraction of light on the ornaments on the angel's robe and the graceful flow of drapery show characteristics of Leonardo's style. It is also thought that parts of the landscape are by Leonardo. Vasari also records that when Verrocchio saw the beautiful results which Leonardo achieved, and that the angel was much better than his own work, he said that he would never paint again.

Devotional Works

Leonardo made many early drawings of the Madonna and Child in which he experimented with various positions, expressions and attributes of both the Virgin and Child. The painting *Madonna of the Carnation* (1478–80) is thought to be partly or some even think wholly attributable to Leonardo, possibly one of his first commissions as an independent artist. The deft handling of the drapery, the subtle chromaticism of the colouring, the gentle face of the Virgin and the dramatic background landscape with misty-grey soaring rock formations pointing to the heavens all support an attribution to Leonardo. In January 1478 Leonardo received a commission to paint an altarpiece for the chapel of San Bernardo in the Palazzo della Signoria. He began work on the commission and in March was paid 25 florins. However, this altarpiece became the first in a long line of works that he did not finish. Given another chance in 1481, Leonardo received a commission for another altarpiece, this time for the monks of San Donato in Scopeto, a church that was attached to the monastery situated not far from Florence.

Although this work, too, was to remain unfinished, it survives today as the *Adoration of the Magi* and is a testament to Leonardo's revolutionary and individual approach. The Virgin and Child and the kneeling kings form a pyramid in the centre of the work evoking a meditative quality in this central section. All around them are figures and horses, which display a huge range of postures, emotions, movements and gestures,

all seemingly involved in an almost primordial flow of existence. The drawing technique confers on the participants a sculptural quality, and the use of chiaroscuro (extreme contrasts of light and dark) and the flow of movement create a dynamic and intense atmosphere. The varied poses, expressions, geometrical positioning and mental states of the participants invoke a cosmos of creativity. The whole work is a display of the interplay of intricate, interwoven characters and scenarios. In *Perspective Study for the Background of the Adoration of the Magi* (*see* page 31) the focus is on the left background. Shadowy figures of people and animals mix together in the chaos.

The Renaissance

Vasari was the first to use the term *rinascita,* which means rebirth, to refer to the arts and literature of his own day. The French historian Jules Michelet (1798–1874) used the French word '*renaissance*' in 1855 to denote a historical period now taken to encompass *c.* 1300 to *c.* 1600. The Swiss scholar Jacob Burckhardt (1818–97) used the term to describe a cultural rebirth applied to Italy and related to the revival of the ideas of the ancient Greeks and Romans. 'Renaissance' also encompasses the idea of a more natural expression of the body, facial expression and gesture as exemplified in ancient sculpture. For much of the Middle Ages the prevailing style was to paint sacred people and themes with a profound respect and awe to emphasize the holiness and other-worldliness of the figures.

The artist Giotto (*c.* 1266–1337) is regarded as the first painter to begin to portray the human figure in a more naturalistic way, with people showing emotion through facial expression and gesture. The vibrant intellectual life of fifteenth-century Florence was to provide a vital further step in creating the concept of the Renaissance, that of new understanding of spatial awareness; Brunelleschi (1377–1446)

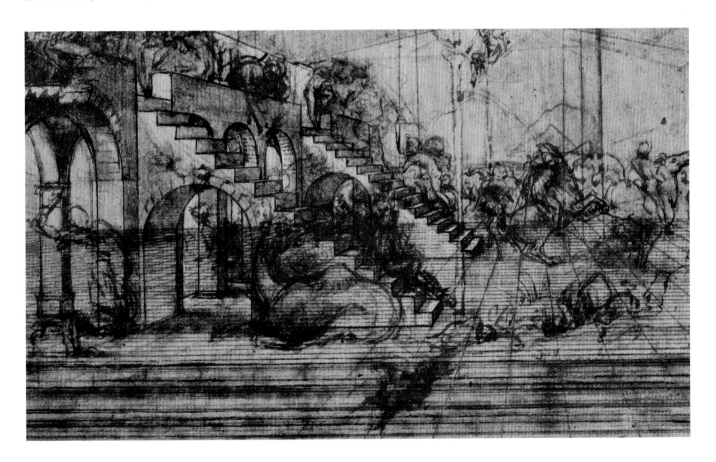

and Alberti (1404–72) are credited with the discovery of perspective, precisely calculated recession and diminution, deriving from the study of optics. Masaccio (1401–28), in his ground-breaking altarpiece *Holy Trinity with the Virgin and John and Donors* (*c.* 1426–28) in the church of Santa Maria Novella in Florence, was one of the first artists, possibly aided by Brunelleschi, to use mathematically calculated perspective, creating the effect of a receding barrel vaulted ceiling.

Living in the Renaissance

In the fifteenth-century Florence was the principal place where all these ideas and principles fused together and came to fruition. It was a city bustling with commerce; it is thought that it had nearly 200 artistic workshops. Wealthy citizens, aspiring to live like the ancient Greeks and Romans, commissioned buildings and works of art, influenced by what they knew of the ancient classical civilizations. Alberti wrote his treatise on Classical architecture, *De Re Aedificatoria* in 1450, and designed the facade of the Palazzo Rucellai (1446–51) in the style of the ancients, based on the Colosseum (AD 70–82) in Rome. The advent of the printing press from around 1440 onwards enabled faster and more efficient and effective distribution of written ideas. Groups of educated citizens, frequently known as 'academies', would meet together in cities throughout Italy to discuss the works of ancient writers and philosophers whose works were becoming increasingly well known due to their

rediscovery and dissemination through the new medium of the printed word. Research into the writings of the ancients had been initially developed by Petrarch (1304–74) who had rediscovered the letters of Cicero (106 BC–43 BC); he has been called the first 'humanist'.

Renaissance humanism was a movement away from what had become something of a rigid medieval curriculum of education called scholasticism. The new movement, enlightened by the teachings of ancient Greece and Rome, although still reverencing the teachings of the Church, sought to revive culture and literature and create well-educated citizens able to speak and write eloquently and clearly. The availability of ancient manuscripts turned into a flood with the coming of many Greek scholars to Italy. Throughout the Middle Ages libraries of the Byzantine empire, whose capital was Constantinople (originally called Byzantium and which is present-day Istanbul), had looked after thousands of ancient documents. When Constantinople fell to the Ottoman Turks in 1453, marking the end of the Byzantine Empire, Greek scholars flooded into the cultural centres of Renaissance Italy bringing with them their precious manuscripts from antiquity. All these events, ideas, inventions and rediscoveries fuelled the fervent boiling pot of creativity in all aspects of life and culture in fifteenth-century Italian cities, among the most important being Florence, Rome, Venice, Urbino, Genoa, Mantua, Ferrara and Naples.

The Medici

Throughout most of Leonardo's lifetime the ruling power in Florence was the Medici family. Their family wealth had been created initially by Giovanni di Bicci de' Medici (1360–1429), principally through banking and commercial activities. His son Cosimo de' Medici (1389–1464) continued to develop the commercial and banking interests of the family. He was also very interested in the revival of the ideas of the ancients and gathered together a collection of ancient texts, particularly Greek, building up the largest library in Europe and setting up an academy to study humanism. Marsilio Ficino (1433–99), the president of the Medici Academy, translated the whole of the works of Plato from Greek into Latin so Cosimo could read them. Cosimo's son, Piero (1416–69) took over from Cosimo and was then followed by his 21-year-old son, Lorenzo (1449–92), who took up his position in 1469, around the same time as Leonardo was beginning his apprenticeship with Verrocchio. By this time the Medici were the wealthiest family in Florence and possibly in the whole of Europe. Lorenzo was known as 'Il Magnifico' ('the Magnificent') and presided over the rich and prosperous city of Florence and its territories as its unofficial yet undisputed 'prince'.

Lorenzo's lifetime coincided with the Italian Renaissance at its height and his death marked the end of what has become known as the Golden Age of Florence. He was very interested in culture, supported the flourishing arts activities of the city and encouraged interest in philosophy and literature. Artists and workshops looked to the Medici and other wealthy families of Florence for commissions to build city palaces and country villas, and to decorate and embellish churches and their chapels. On Easter Sunday in 1478 during the service of Mass, Lorenzo and his brother Giuliano were attacked. Giuliano died but Lorenzo survived with minor injuries. This conspiracy to bring down the Medici, which has become known as the Pazzi Conspiracy, was found to have been promulgated by a rival Florentine banking family, the Pazzi, supported by Pope Sixtus IV, the Archbishop of Pisa and the King of Naples. Conspirators were tracked down and killed and their bodies then displayed hanging outside the Palagio del Podestà. In 1479 Leonardo sketched the hanging body of one of the conspirators, Bernardo di Bandino Baroncelli, who had been put to death and then suspended outside the Palace. Next to the sketch, Leonardo listed what Baroncelli was wearing, possibly with a view to receiving a commission for a painting related to the event.

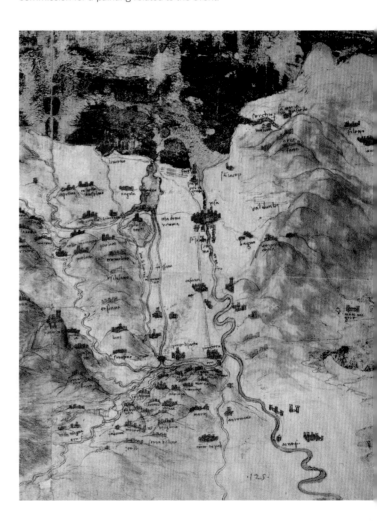

Bronze-casting

One particular aspect of the renaissance of ancient ideas and inventions, which was to affect the life and work of Leonardo significantly, was the revival of interest in casting statues in bronze. Life-size equestrian bronze monuments from antiquity were known in the fifteenth-century through the statue of the Roman Emperor Marcus Aurelius (AD 121–80) in Rome and through the four bronze horses standing on the pediment above the Basilica of San Marco in Venice,

which were renowned for their beauty and magnificence. Taken from Constantinople *c.* 1204 and thought possibly to have come from Alexandria in Egypt before that, they were considered a marvel from the ancient world. The revival of ancient techniques enabled Donatello to cast the first equestrian statue for 1,000 years with his monument of the mercenary soldier Erasmo da Narni (*c.* 1370–1444), commonly known as *Gattemelata* (honey cat), which stands in front of the Santo church in Padua.

Verrocchio, having trained in a goldsmith's workshop, was experienced in this type of work and was regarded as the most important bronze-caster in Florence. One of his most important commissions *c.* 1478, which was when Leonardo was possibly still at his workshop, was to cast a bronze equestrian statue for the Republic of Venice of the mercenary soldier Bartolomeo Colleoni (1400–75). Colleoni was to be seated on his horse, which would have its left leg raised, thus providing

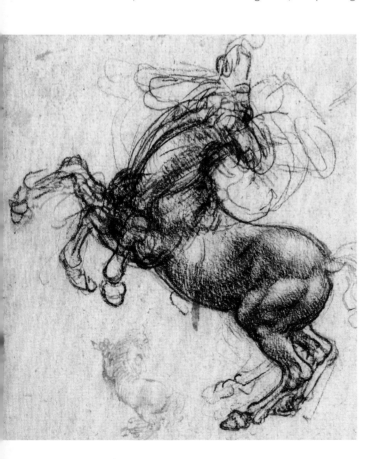

a new challenge in the casting of bronze statues. It is thought that Leonardo, fascinated by horses and making many drawings and studies of them throughout his life (for example *see* page 46), may have travelled to Venice with Verrocchio to discuss the project and may even have had some input in the design.

Guild of St Luke

In 1472 Leonardo completed his apprenticeship with Verrocchio and became a member of the artists' guild in Florence, the *Compagnia di San Luca*. In the guild's record books can be found Leonardo's name and a note that he had paid his subscription. He was only 21 years of age but he was now officially recognized as an independent professional artist. Often artists would stay for some time in the workshop where they were trained and it seems that Leonardo remained at Verrocchio's workshop for some time.

Earliest Documented Drawings

Although clearly Leonardo must have done many drawings as a young artist to develop the level of skill that he attained, they have not survived or been found yet. The first documented drawing by Leonardo is a study entitled *Di Santa Maria delle Neve* (*On the Day of St Mary of the Snow Miracle*) dated 5 August 1473, now usually called *Arno Landscape* (*see* page 104), which bears many of the hallmarks, themes and styles of his developing art. It has been referred to as 'the first landscape drawing in Western art'. In it he includes a castle, a mountain peak, a view of marshlands and the Arno River in its broad valley. It may possibly have been a preparatory drawing for the background of a work; often artists painted a row of windows behind the central picture scene through which a landscape could be viewed.

What interested Leonardo more than straightforward depiction was the attempt to capture the essence of natural phenomena. The effects of light and wind, the creation of atmosphere and the desire to convey the experience of the elements are displayed in this early drawing. Leonardo used hatching to create depth and yet at the same time evokes transparency in light itself and the effects it created. Even the title and date convey the paradox of the conception behind

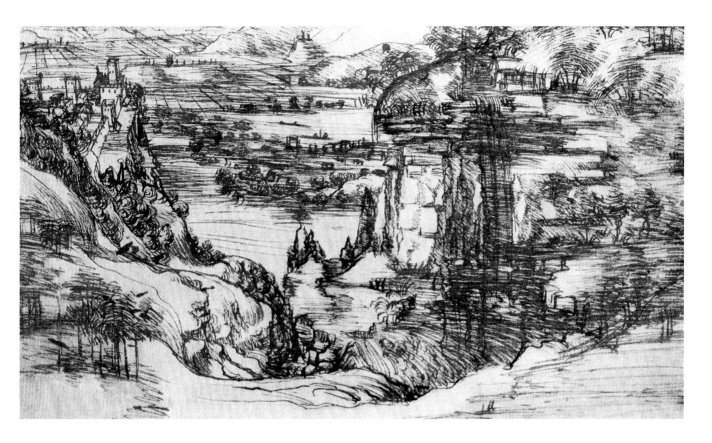

the work: it is August and yet the title refers to *neve* (snow), and so the elemental nature and sometimes random effects of weather systems beyond the power of man to control and engage the mind of both the artist and the viewer.

Public Disgrace

Trying to date works and develop a chronology for Leonardo is difficult as many papers have been lost. However, it is possible to state that Leonardo was still working in Verrocchio's workshop in 1476 due to an accusation made against him, which court documents confirm. He was anonymously accused, together with three other men, one from the wealthy Tornabuoni family, of sodomy with a young man of 17. Without any evidence all charges were eventually dropped, possibly through an intervention by the Tournabuoni family. Leonardo's reputation and career could have been badly damaged if the accusation had been upheld as punishment could include death, prison or banishment from Florence.

Dragons and Demons

Vasari tells the story of how Leonardo's father was asked by a peasant from Vinci if he could have an illustration painted on a wooden shield for him. Piero is said to have taken it to Leonardo to be painted. Leonardo, Vasari relates, gathered a variety of creatures together into one room: 'Lizards, great and small, crickets, serpents, butterflies, grasshoppers, bats and other strange kinds of suchlike animals.' He composed a monstrous creature but one depicted in a rational, scientific way. Using chiaroscuro, mixing light and dark shadow to create an illusion of depth and drama, Leonardo created a dragon amid rocks, its mouth open, breathing steam which 'turned the air to fire'. Vasari describes the creature as 'most horrible and terrifying, belching forth venom from its open throat'. He records that Piero was shocked on seeing the threatening, violent creature, but recognizing its artistic merit he gave the peasant another shield with a different illustration and sold the dragon-shield to a merchant for 100 ducats who then sold it to the Duke of Milan for 300 ducats.

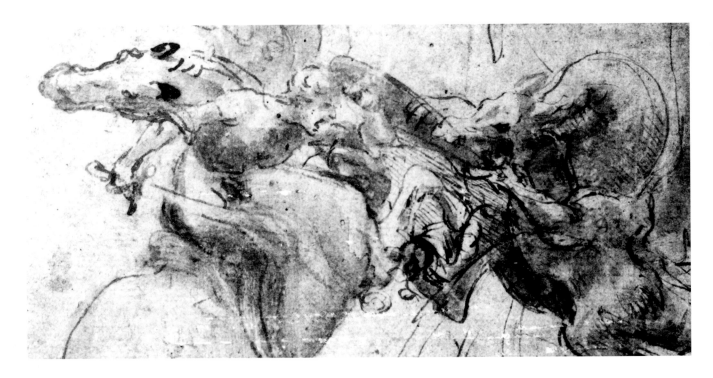

This work is the first by Leonardo to be described in detail, that deals with an imaginary and fantastical world, a theme which was to be a lifelong interest for him. In *Battle Between a Rider and a Dragon c. 1482* (*see* page 32) we can feel the visceral power of the dragon as it attacks the horse and rider in a fearful encounter. In the same narrative Vasari refers to Leonardo wanting to create the same effect with the shield painting as he once had achieved with the head of a Medusa. Medusa was a figure from Greek mythology who had snakes entwined around her head; if anyone looked at her they would be turned to stone. This work is now lost but around 1596–98 Caravaggio (1571–1610) painted a copy of it. From Caravaggio's copy we can see Medusa's terrifying face, half in shadow, mouth wide open, raging and shouting, with writhing snakes instead of hair.

Transition

Leonardo frequently mentions in his notes that he feels that the lack of his formal education in Latin and Greek is a disadvantage to him in the academic and literary Florentine circles. He was clearly talented in many fields and was looking to develop his skills and experience designing projects and schemes, which would challenge his intellect and abilities. His opportunity came when Lorenzo sent him as a cultural ambassador to Milan with the musician Atalante Migliori to present the gift of a silver lyre made in the shape of a horse's head. We do not know if Leonardo himself designed and made this piece but it was an impressive and thoughtful diplomatic gift to the Sforzas, the ruling family of Milan whose symbol was a horse's head.

Seemingly challenged and stimulated by the opportunities Milan could provide, Leonardo wrote a letter to the ruling Ludovico Sforza (1452–1508), known as *Il Moro* (the Moor), due to his dark colouring, offering his services. The letter mentions that he can paint as well as any man, create sculpture and develop architectural projects. However, Leonardo also mentions his ability to guide and redirect water, and particularly emphasizes his skills as a military engineer, offering to develop mines, guns, mortars and other projects useful in time of war. One particular project he says he is able to bring to fruition is a plan to create a bronze horse in memory of Ludovico's father. There is some doubt as to whether this letter was actually sent, but in 1482 Leonardo left Florence to work in Milan.

Milan

Ludovico was ambitious for Milan, looking to create a cultural centre that would rival Florence and the other Renaissance courts of Mantua, Ferrara and Urbino. It was a wealthy and industrious city and as such attracted the envy of other European states, necessitating an emphasis on the development of military might to defend against invasion. Leonardo did not gain employment at the court straight-away but set up independently as an artist and took on associates and pupils including Ambrogio de Predis (*c.* 1455–*c.*1508) and Boltraffio (1467–1516), among others. In July 1490 he took on a 10-year-old servant boy with angelic looks and the beautiful curls of hair that Leonardo so admired. Gian Giacomo Caprotti (*c.* 1480–1524) was from a poor farming family and although blessed with good looks, it appears that his character was not so pleasing. In the margin of his diary Leonardo has written 'thief, liar, obstinate, glutton' and tells how he found the boy stealing money from his purse. Although he gave him the name Salai, which means 'demon', Leonardo kept the boy on and provided for him. Even though many times he was caught stealing and misbehaving, he remained a servant and constant companion for Leonardo throughout his life.

Works in Milan

Leonardo's workshop became known for its refined, elegant work, which had a unity of conception and form, and a subtle use of shadowing known as *sfumato*. He painted innovative portraits including one known as *Lady with an Ermine* (*c.* 1489–90), which displayed his use of rich colouring, delicate effects and the lifelike representation of the soft and furry ermine. In April 1483 Leonardo was commissioned by the Confraternity of the Immaculate Conception to paint an altarpiece that showed 'Our Lady' for the oratory of San Francesco Grande. It was to be produced in collaboration with the de Predis brothers, Ambrogio and Evangelista, who would paint the side panels, while Leonardo would paint the central panel. It was planned to take seven months; however, the painting was still unfinished when Leonardo left Milan in 1499. Problems with payments for extra materials seems to have been an issue, and it may be that Leonardo sold the picture when the extra payments were not met.

In 1506 the Confraternity suggested a new contract, which would include payment for the earlier expenses if Leonardo would finish the work. Finishing the first version did not seem to have been possible so Leonardo began a second version called by the same name, *Virgin of the Rocks*. The first version is now in the Louvre in Paris, the second in the National Gallery in London. Both reveal a style that would be adopted by Leonardo's followers. The works are set in a dark, shadowy grotto with mysterious rock formations in the background. Halos, innovative reflections of light, interaction between the figures and an

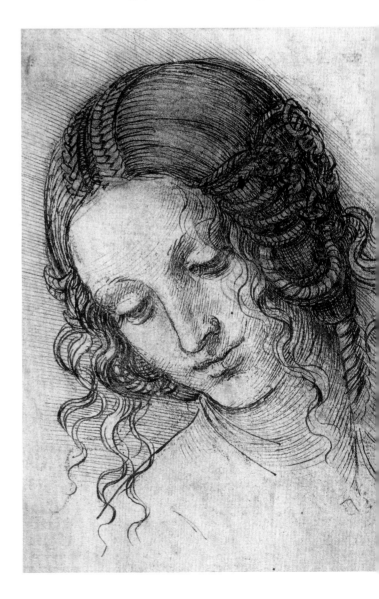

overall sense of the elemental nature of spiritual revelation create
compelling scenes of an almost religious mysticism. Meanwhile, at
court Leonardo was able to use his technological knowledge and
artistic skills to create fantastical displays for official occasions.
At the wedding of Gian Galeazzo II Maria Sforza (1469–94) to Isabella
of Aragon, Princess of Naples (1470–1524) in 1488, Leonardo
was appointed to create scenery, costumes and stage sets for the
production entitled *La Festa del Paradiso* (*The Feast of Paradise*).

Drawings

Leonardo used large pieces of paper for his drawings, usually
32 x 44.6 cm (12 x 17 in). On each sheet he would draw a variety of
images, sketches and outlines often linked around a certain subject,
which led the scholar Carlo Pedretti (b. 1928) to call them 'theme
sheets'. Some sheets, however, would contain a mixture of ideas on
different topics, jotted down as Leonardo's fertile mind ranged from
one subject to another. Many of these larger sheets over the centuries
have been cut up in attempts to classify drawings under different
headings, a notoriously difficult challenge. One of his favourite methods
of drawing was what is known as silverpoint technique, using a thin
silver wire in a holder. He often simply used pencil, pen, charcoal
and chalk, with some of his drawings being executed in red chalk.
Leonardo's early drawings of drapery, when he was studying in
Verrocchio's workshop, are examples of the virtuosity of his work.

Preparatory drawings for his paintings include a number of heads of
the Virgin, which have been considered some of the finest achievements
of all draughtsmanship (*see* page 54). The study of faces, both ideal
and grotesque, was a particular interest and furnished individual
physiognomies for Leonardo's many works; for example, *Adoration
of the Magi*, which is brimming with contrasting characters. Many
preparatory drawings for heads of warriors exist that were to be used
for battle scenes (*see* page 30). Searching beyond the purely physical,
Leonardo writes: 'The signs of the face partly show the nature of men,
their vices and their constitutions.' Leonardo, like many of his
Renaissance contemporaries, loved allegories, puzzles and symbols
(*see* page 41). He drew what he saw in life and in nature; for example,
drawing detailed studies of crabs while at the same time questioning
why shells of creatures were found in the strata of mountains. Whoever
and whatever Leonardo saw around him in life was material for his
draughtsman's pencil, and the issues that were raised stimulated his
creative and searching mind.

The Bronze Horse

The commission of a monument as a memorial to Francesco Sforza
(1401–66) occupied Leonardo's thoughts and talents for a number of

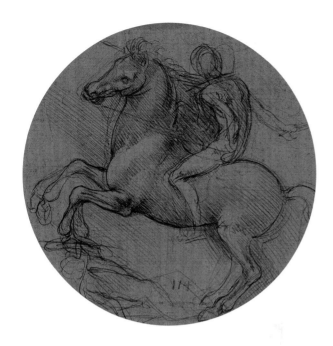

mechanics and physics. In order to deepen his knowledge of the effects of wind resistance and currents, he made a study of aerodynamics. Without an internal combustion engine, it was impossible to achieve the upward lift that was required but Leonardo famously described and drew a machine that in essence was the precursor of the helicopter and also anticipated the advent of the modern-day glider and parachute.

Further studies led Leonardo to consider the nature of the universe and to write about the cosmos, ideas that Galileo (1564–1642) later developed. Behind this yearning for flight can be traced deeper philosophical issues, such as a desire to experience the immensity of the world and its terrains, to expand the limits of man's possibilities and to move into new areas of previously unknown freedoms.

years. The Sforza horse was to be more than 7 m (23 feet) high, double the height of Donatello's *Gattemalata* in Padua and Verrocchio's statue *Colleoni* in Venice; it was intended to be the largest bronze monument ever to be cast. The clay model was finished by 1495 and elicited admiration from everyone who saw it. Unfortunately, the bronze that had been allocated to cast it had been sent to the Duke of Ferrara, Ludovico's father-in-law, who had requisitioned it in order to make a canon to use against a possible French attack. After the French invaded Milan in 1499, the clay model was destroyed by their troops who used it for target practice. All that remains to us today are some notes and sketches concerning equestrian statues (*see* page 34).

Leonardo and Flight

Leonardo was fascinated by the Greek myth of Icarus who tried to fly using feathers and wax, and in the pages of at least nine of his notebooks he explored the idea of flight. His studies of the flight of birds and how these principles could be adapted and used by humans involved him in deep observation and creative imagination. While in Florence between 1487 and 1490, he experimented with drawing flying machines that had wings, which flapped like those of birds. Moving on from this, he began to apply principles from other areas of study, such as

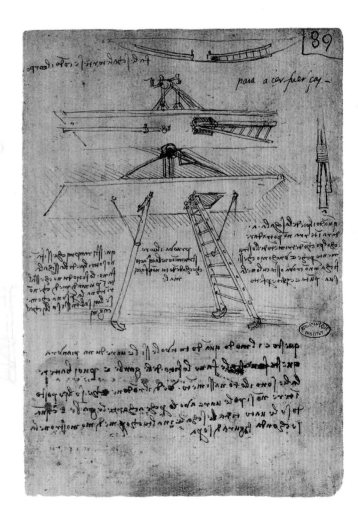

The Last Supper

Leonardo was now known
at the Sforza court
as 'the Florentine
Apelles', a reference
to the acclaimed
painter of classical
times (*fl.* fourth
century BC).
After the abrupt
ending to the
bronze horse
project, Ludovico
now offered Leonardo
the commission to paint
the *The Last Supper*
(*L'Ultima Cena*) for the
refectory of the convent of Santa
Maria delle Grazie, of which Ludovico was
patron. This exceptionally large work (460 x 880 cm, 181 x 346.5 in)
was to fill the narrow wall of the rectangular room. Leonardo's plan was
that as someone entered the refectory they would feel as if they could
step into the painting, which appeared to be a continuation of the
refectory itself, receding towards windows at the far end, with doors of
the monks' cells painted along the side.

The concept and design of the work was ground breaking and it
became Leonardo's most famous and acclaimed work among his
contemporaries. In effect, it was an opportunity for Leonardo to
synthesize his ideas over a range of subjects in the fields of optics,
architecture, anatomy, harmony and perspective. It gave him the
opportunity on a grand scale to express his theories about the
intellectual aspects of art. Always keen to experiment, Leonardo
decided to try out a new technique for wall painting using tempera
mixed with oil, which very soon resulted in the work beginning to
deteriorate. Poor quality attempts to restore the work over the years
have generally made it worse, although recent attempts have been
more successful.

Leonardo the Mathematician

Leonardo was popular at the Sforza court and found the company
of the many learned visitors and residents to be stimulating and
interesting. Donato Bramante (1444–1514), the architect and painter,
was resident at the court and he and Leonardo worked together and
became friends. Leonardo was always fascinated by mathematics,
so it was most useful for him to further his studies with the
Franciscan monk Luca Pacioli (*c.* 1445–*c.* 1517), the renowned
mathematician, who was also resident at the court. Pacioli was the
author of a treatise on geometrical proportions called *De Divina
Proportione* to which Leonardo contributed the many geometrical
illustrations. Pacioli was very supportive of Leonardo at court and
praised Leonardo's treatise on painting and movement, now lost.

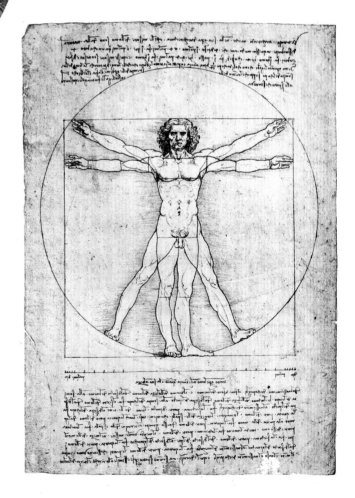

From his early years Leonardo had been fascinated by mathematics and geometry, which, together with music, he considered to embrace everything in the universe, thus linking them with the concepts of the universal and the absolute. Although he was not particularly competent in arithmetic, he excelled in the study of geometry and was fascinated by the study of proportions. His pen and ink drawing with a written commentary *The Proportions of the Human Figure (c.* 1492), commonly known as *Vitruvian Man,* has achieved iconic status (*see* page 109); this drawing formed the frontispiece to Pacioli's treatise on proportion. Pacioli drew on the ideas of Vitruvius in the writing of his thesis. Vitruvius was a Roman architect and engineer in the first century BC. His treatise *De Architectura Libri Decem* (*Ten Books on Architecture*) was written around 30 BC and is the only surviving architectural treatise from antiquity. In Book Three he discusses the relation of the human form to architecture. The treatise had no accompanying images and was difficult to understand so a variety of interpretations are possible. The circle and the square are considered to be the perfect forms, and Leonardo in his drawing attempts to 'square the circle' by showing that man positioned in the centre as a symbol of perfect harmony fits into these two perfect forms, standing straight with arms outstretched and also with feet in motion and arms lifted up.

Return to Florence

In 1499 Ludovico Sforza was obliged to flee Milan and go into exile in Germany before the advancing French forces of Louis XII (1462–1515). Leonardo had made some preparations in the event of the fall of the Sforza court by sending money to his bank in Florence, and in December he left the city with Luca Pacioli and his servants and assistants. The party went first to Mantua where Leonardo drew a portrait of Isabella d'Este (1474–1539). She was clearly pleased with the work because she tried to persuade him to also paint her in oils – but to no avail. Shortly afterwards Leonardo went to Venice and worked briefly as a military engineer advising on defence systems in the event of an attack by the Ottoman Turks. In 1500 he was back in Florence. The rule of the fervent Friar Savonarola (1452–98) was now over, the Medici were in exile and the city was now a republic with citizens keen once more to commission new works of art. Leonardo began preparatory studies for a *Virgin and Child with Saint Anne,* which he never finished.

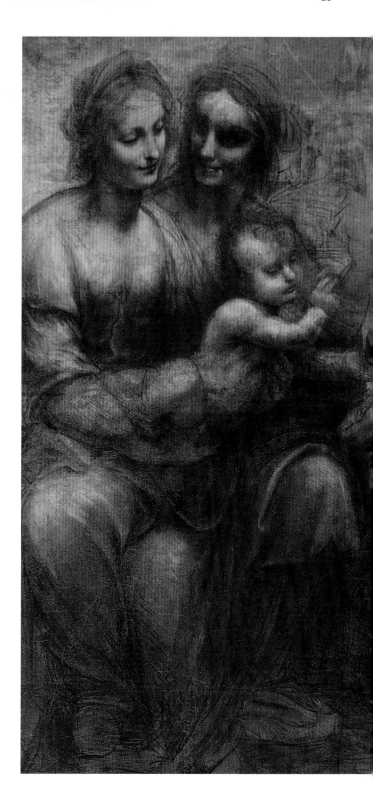

The cartoon, a large detailed preparatory drawing of great beauty and distinction, is now in the National Gallery in London. During this period Leonardo also travelled to Rome where he studied the Emperor Hadrian's villa at Tivoli and made notes on the mills along the River Tiber. He advised on plans for a villa for the ruler of Mantua, and in Florence his advice was sought on an architectural problem concerning the stability of the church of San Miniato al Monte.

Leonardo the Engineer and Cartographer

In the summer of 1502 Leonardo left Florence and took up a post as 'familiar architect and general engineer' for the Captain General of the Papal militia, the notorious Cesare Borgia (1476–1507). Leonardo's responsibilities included designing military equipment, defence fortifications and creating maps and drawing plans. He travelled throughout Emilia-Romagna, The Marches, Umbria and Tuscany, keeping detailed notes and sketches in his notebooks. *A Plan of Imola* (*see* page 110) is a wonderful blend of cartography and art, while his *Physical Map of Tuscany, Emilia and Romagna* provides a beautiful and sinuous depiction of the landscape from above. During the period he was working for Cesare Borgia, Leonardo was also in correspondence with the Sultan Bajazet II (*r.* 1481–1512) concerning his proposal to build a bridge across the Bosphorus at Istanbul. This would have been the biggest bridge ever built but the Sultan and his advisers rejected the proposal as being unworkable; however, a team in Norway in 2001 constructed the bridge according to Leonardo's proposals and it was proven that his engineering calculations were correct.

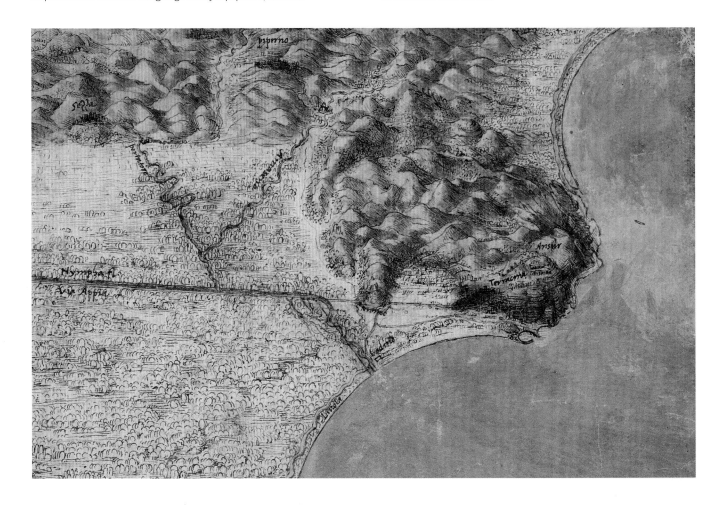

Leonardo's designs for military equipment were many, including one for a prototype military tank. Others provided designs for new types of cannons and bombs. As regarding defensive systems, his fertile mind suggested the use of passages that could be flooded or set on fire, and secret staircases. In August 1503 Cesare Borgia's rule collapsed; he fled to Spain and Leonardo went back to Florence. On a visit to Piombino in 1504 to advise on fortifications, he made several suggestions including the construction of trenches and a covered road. Adapting drawings by other architects and engineers for the port of Piombino he proposed square towers and semi-circular walls behind a larger wall, and also buildings that projected outwards over the sea.

The Mona Lisa and The Battle of Anghiari

Around 1503 Leonardo agreed to paint Monna Lissa, the wife of Francesco del Giocondo; Vasari tells us that he worked on it for four years and it still remained unfinished. The work is subtle and atmospheric with a background landscape that evokes the mystery of nature and the essence of time and space. The sitter's enigmatic smile has become famous for its calm satisfaction and air of detachment. Leonardo may have made the smile such an integral part of the work to highlight a play on the name 'Giocondo', which means 'cheerful one'. Leonardo kept this work with him for the rest of his life and on his death it passed to Salai, who then left it to his sisters who sold it. It eventually came into the collection of the French king Francis I (1494–1547). At around the same time, Leonardo was asked by the Council of Florence to paint a mural for the Palazzo della Signoria depicting the victory of Florence over Milan at the Battle of Anghiari in 1440. On another wall in the same room Michelangelo (1475–1564), Leonardo's rival, was asked to represent the Battle of Cascina (1364) when Florence won victory over Pisa.

Although Leonardo was around 50 years old and Michelangelo only 27 years old, both were supremely talented and competitive, and there was friction and animosity between them. Michelangelo considered himself to be primarily a sculptor, a profession that Leonardo considered to be dirty and messy. He writes in his notes that in the street Michelangelo ignored him and also at times made derogatory remarks about the unfinished bronze horse project. Leonardo prepared the

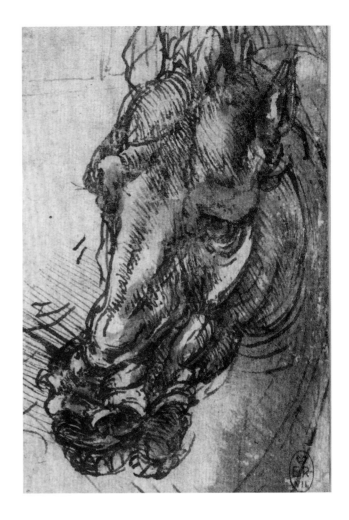

cartoon and created sketches for the enormous Anghiari battle scene and did manage to complete the central panel before leaving Florence. However, his experimental use of pigments led to problems with the paint and the work soon began to deteriorate. Vasari, in his role as artist, was asked to redecorate the wall in 1563. Many art historians think that Vasari would not have painted over Leonardo's work and it has been suggested that he built a thin screen and painted his own work on top. In the top right-hand corner of Vasari's mural can be found the two words 'Cerca Troval' ('he who seeks finds'), and some consider this to be a challenge to find Leonardo's lost battle scene. Michelangelo did not even progress as far as Leonardo with his work on the Battle of Cascina; the cartoon was left unfinished when he left Florence to work in Rome in 1505, having been summoned by Pope Julius II.

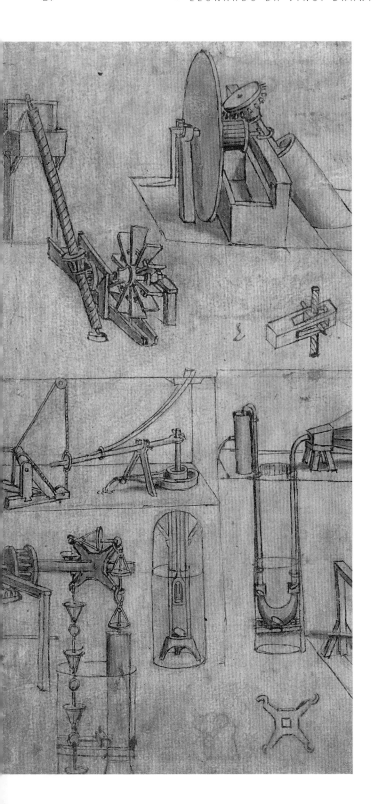

Leonardo and Science

Leonardo's research and the creation of designs for engineering and scientific projects often represented an advance in knowledge and in the understanding of scientific precepts. He used the individual example of an object as a point of departure, seeking to fully understand all its aspects, and searching for universal principles, before moving on to explore ways to develop and transform it. He designed spinning frames, mechanical looms, machines for grinding, types of cart and even a prototype automobile. He devoted many pages to the study of clocks and applied clockwork principles to other objects and machines. He also investigated the striking of clocks in relation to music, and given his endless fascination for water, it is unsurprising to discover his research into water clocks. He greatly admired the loom as being an invention that brought many benefits, saving time and energy; and his suggested improvements and developments of it anticipated the Industrial Revolution and even the principles of robotics.

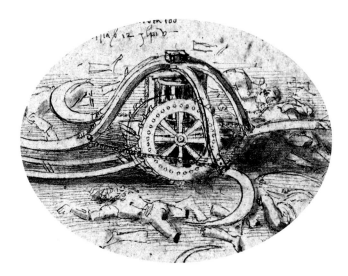

Leonardo was very interested in the science of optics and particularly how it related to the science of representation. His development of tonal chromaticism of colour to create the effect of a receding landscape in the backgrounds of his works was much copied by other artists. For Leonardo, ultimately science, architecture, engineering, design, painting and optics were all paths to the main aim of knowing the world and entering into the world of the poetic imagination beyond.

Milan and Rome

In 1506 the French governor now in charge of Milan, Charles d'Amboise, ordered Leonardo to return to Milan because of a lawsuit over the unfinished *Virgin of the Rocks*. Leonardo very quickly found himself working for this new governor and designed a villa for him, which was never built, with spectacular water features in the garden inspired by the fountains of classical times. From 1508–10 Leonardo worked on a project to create an equestrian statue in memory of Marshal Gian Giacomo Trivulzio who had left 4,000 ducats in his will for that purpose. The statue was to be in the style of the former Sforza horse, although not as big. Leonardo's drawings in 1508–11 for the statue show various possible overall designs and suggested positions for the horse and rider. In 1513 the French lost control of the city to Massimiliano Sforza, Lorenzo's son, and this project was also one of the many that remained unfinished. Also in that year Giuliano de' Medici, brother of the newly elected Pope Leo X, called for Leonardo to come to Rome and provided him and his retinue, which included Francesco Melzi (*fl.* 1491–*c.* 1570), his well-born, well-educated assistant, with accommodation in the Belvedere wing of the Vatican, where he stayed for three years.

Rome at this time was a hotbed of artistic and creative activity. Bramante was rebuilding St Peter's Basilica, Raphael (1483–1520) had just completed his paintings for the Vatican apartments, Michelangelo had finished the ceiling of the Sistine Chapel and was again working on the sculptures for the tomb of Pope Julius. Vasari tells us that in Rome Leonardo spent much time on philosophical studies and conducting experiments involving creating models of animals, which he filled with wind and blew through the air. Many scholars consider that Leonardo created his painting *St John the Baptist* in Rome during this period. The Baptist exhibits a strange Mona Lisa-like smile and his right-hand index finger points upwards toward heaven, indicating the coming of Christ. In 1514 Leonardo went on a tour, visiting Parma and Civitavecchia, possibly working as a military engineer for Giuliano who was the Captain General of the Papal militia. Back in Rome, documents reveal that relations with Michelangelo had become more strained than ever, although Michelangelo soon left the employ of the Medici and returned to Florence in 1514.

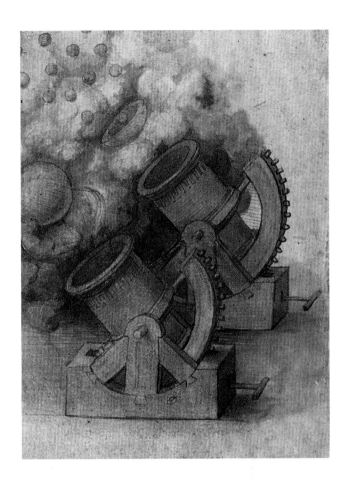

Leonardo and Anatomy

Through his research into the human body and his anatomical drawings, Leonardo was not simply trying to find out how the body works, but was also seeking the very essence of being. In a number of passages in his writings he explores the human soul through the means of the body. Over the many years of research his drawings developed from being sketches to being works of art; his aim had now become the combination of scientific observation with the aesthetic description of the human body. In 1510 he began a new series of anatomical drawings based on his experience in the dissection of corpses. Dissection was legal only for members of the medical profession but Leonardo managed to get access to cadavers at the Ospedale di Santa Maria Nuova in Florence, which also happened to be his bank.

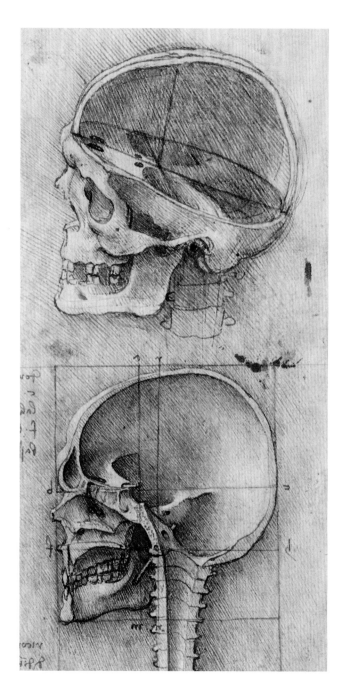

human body. He researched muscles, circulation, the heart, the brain, the skeleton and the skin. He frequently used the technique of drawing from different viewpoints so as to build up a type of three-dimensional representation. He looked around the subject, viewed it from above, examined the underside and studied it from every angle and position in a systematic manner. He created sectional views and removed some parts so as to see better what was underneath. The analysis was wide-ranging and in depth, and the drawings appear strikingly modern in their conception and depiction, as well as being a formidable combination of beauty and science.

Amboise

After the death of Giuliano in 1516, Leonardo accepted an invitation from the King of France, Francis I to join his court at Cloux near Amboise, giving him the position of 'First Painter, Engineer and Architect of the King'. Leonardo, again with his entourage, travelled to Cloux in the winter of 1516. Vasari marvels at the fact that although Leonardo did not seem to work very much, he always had assistants and servants. Leonardo stated that he was unconcerned about material things writing that: 'Poor rather is the man who desires many things.' It is true that his many outstanding talents endeared him to rich patrons who provided for him and his retinue. Francis I was no exception and gave Leonardo a generous salary and a beautiful manor house near the court with ample room for his entourage. The house was linked by an underground passageway to the Chateau d'Amboise where the King lived. Francis considered him to be 'a very great philosopher' and it seems that most days the two would converse on many subjects. With the help of his assistant, scribe and now carer, Melzi, Leonardo embarked on the project to organize his notebooks with a view to publishing books on anatomy, architecture, engineering and painting, although this never came to fruition in his lifetime; the first printed edition of his *Treatise on Painting* was published in 1651 in Paris.

Other artists such as Donatello, Michelangelo and Raphael also managed to gain first-hand experience of dissection but none appear to have gained such a deep knowledge as Leonardo, whose agenda went beyond simply being better equipped to draw and paint the

According to a document of 1517, Leonardo now suffered from paralysis of the right hand but he continued to draw and designed room sets, mechanical scenery and costumes for festive occasions at the court. He also completed a successful canal project south of the Loire River and did much work on an architectural project to create a new royal palace at Romorantin, which was partly built before it was decided to change its location. By the age of 67 in 1519, Leonardo had become increasingly frail. Vasari wrote that he died in the King's arms but this is more likely to be a romantic myth. Vasari records that Leonardo was mourned 'beyond measure' by all who had known him 'since there was never anyone who did so much honour to painting'. Although he was one of Italy's most illustrious men, Leonardo had requested that he be buried in the cloister of the church of Saint-Florentin in Amboise, unlike Michelangelo whose body in 1564 was stealthily removed from Rome at night and taken back to Florence. In his will, Leonardo left money to alms houses, bequests to his seven half-brothers, and gifts of goods to his servants. Melzi, who had been with him since 1507, received the precious notebooks, all tools and pictures. Salai was left certain named paintings, including the *Mona Lisa* and a house and garden in Milan.

Leonardo's Legacy

Leonardo's influence on painting and theory was immense. His compositional arrangements; his innovative approach to the depiction of landscape; the complexity and subtlety of detail; the transitions of shadow and light; the interplay of light and shade on objects; concern for naturalism; the misty, almost metaphysical backgrounds blended with *sfumato*; the gradual transition of tone from one hue to another; deep empathy with the natural world; the vast range of gesture and expression; the subtle range of emotional effects that convey intention and inner meaning – all were studied and emulated by aspiring artists. Copies, variants and engravings of his works were many. The fusion of art and science that occurred in his drawings provided intellectual challenge to artists and scientists alike across a wide spectrum of practical, conceptual and philosophical issues. With the rise of the 'Grand Tour' of Europe, which English aristocrats made in the eighteenth century, there was a revival of interest in Leonardo's works.

The paintings and notebooks bequeathed to Melzi and Salai eventually found their way into private collections and then into major national galleries and museums. So much about Leonardo's works and life is still clouded in uncertainty and this has added to the myth that has grown up around him. One thing that is certain is that he was a towering genius, amazingly multi-talented, an intellectual colossus who well deserves the accolade of *l'uomo universale* – 'the universal man'.

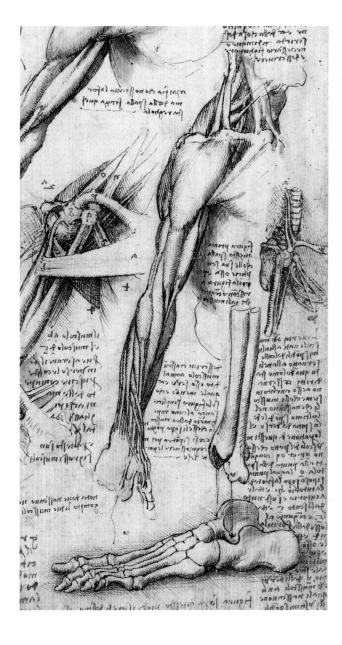

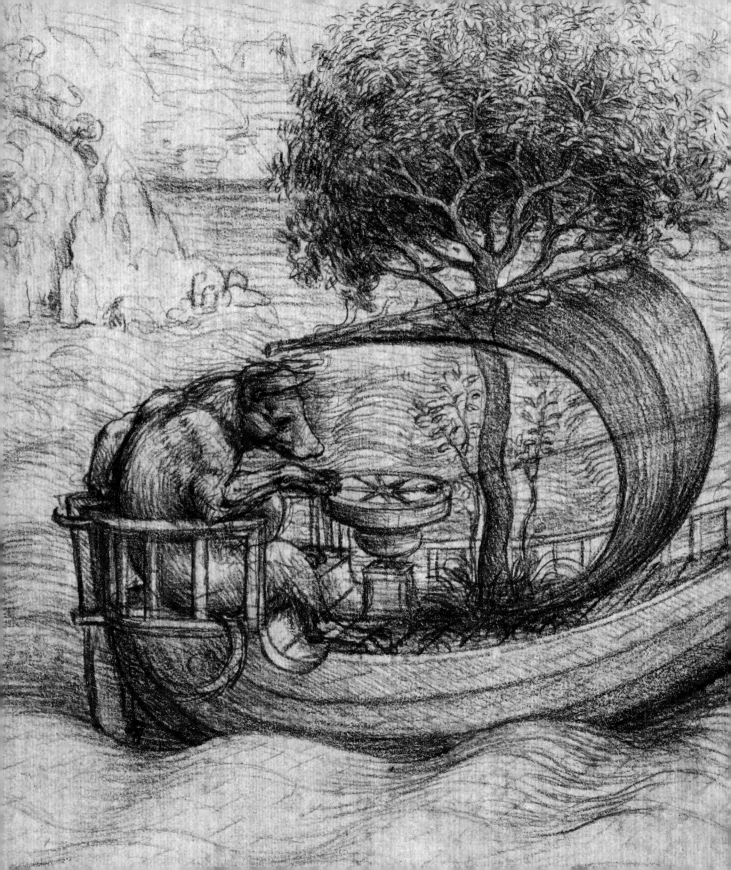

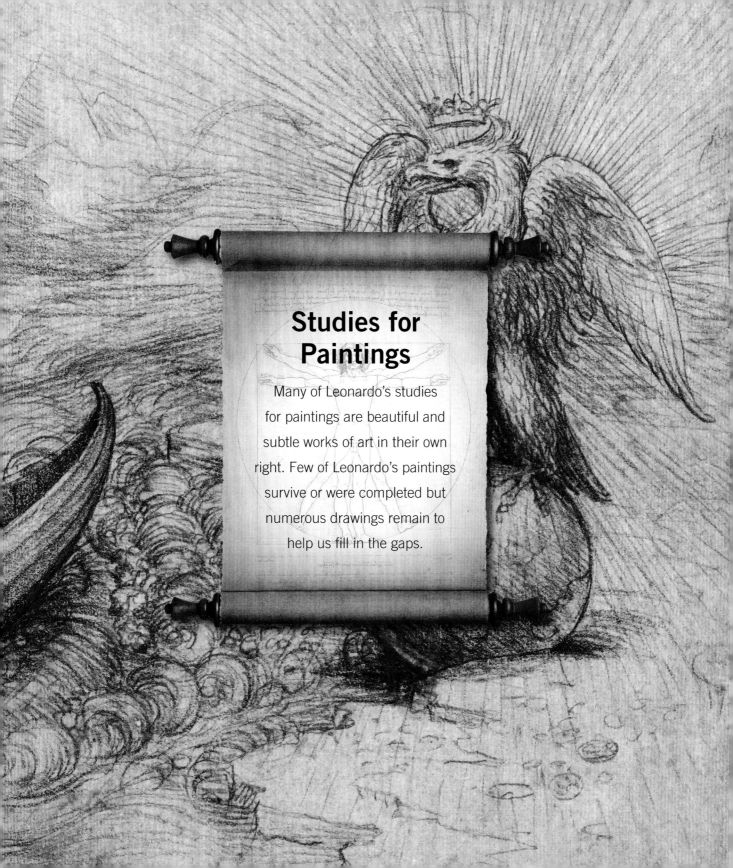

Studies for Paintings

Many of Leonardo's studies
for paintings are beautiful and
subtle works of art in their own
right. Few of Leonardo's paintings
survive or were completed but
numerous drawings remain to
help us fill in the gaps.

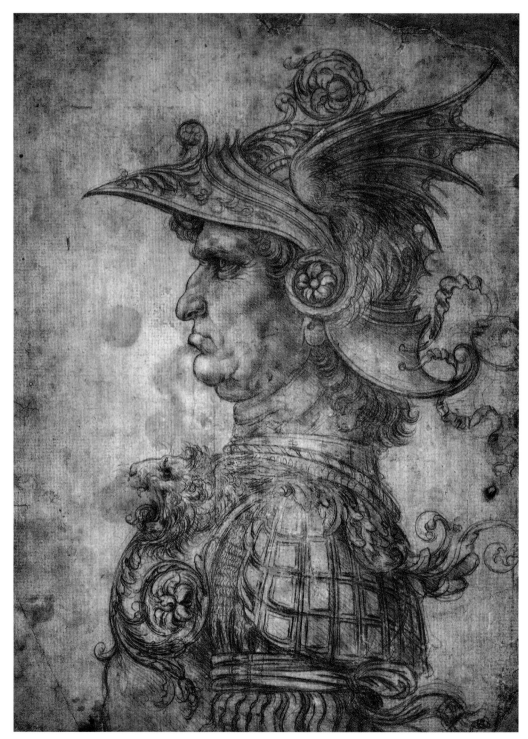

Profile of an Ancient Captain, also known as Condottiero, 1472
Silverpoint on prepared paper, 28.5 x 20.7 cm (11 x 8 in)
• British Museum, London

This drawing of a warlord was made when Leonardo was still in Verrocchio's workshop and shows some similarities with Verrocchio's style. The helmet is decorated with wings and the breast plate with a lion's head.

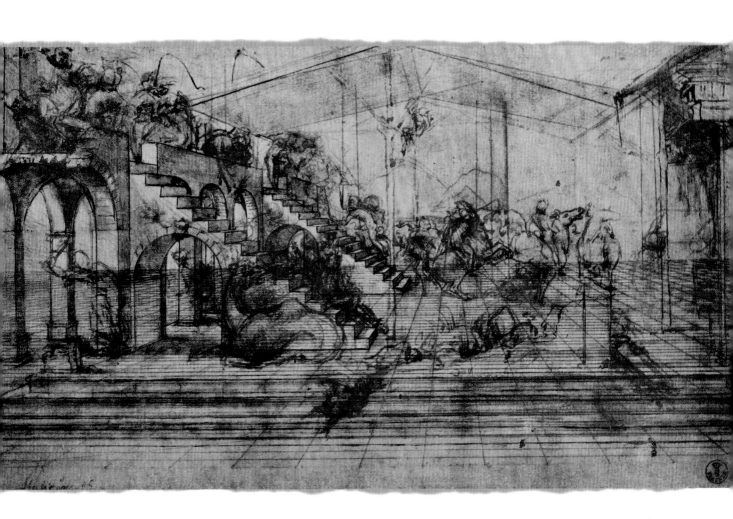

**Perspective Study for the Background of
the Adoration of the Magi, 1481**
Pen and ink on paper, 19.6 x 30.8 cm (7¾ x 12 in)
• Galleria degli Uffizi, Florence

Leonardo here is experimenting with the placement in space of the many architectural features, figures and animals that fill the final canvas of his painting. Study sketches such as this give an idea of how much thought and work went into the alterpiece.

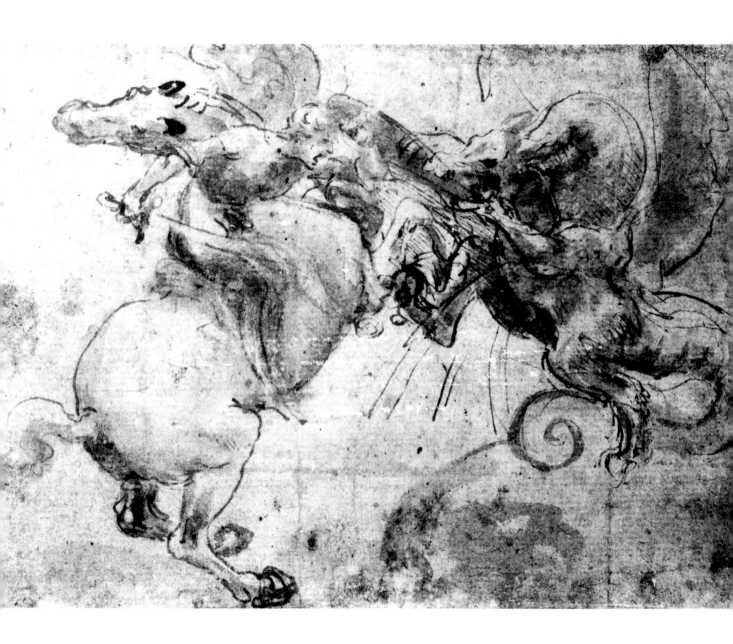

Battle Between a Rider and a Dragon, *c.* 1482
Stylus underdrawing, pen and brush on paper,
13.9 x 19 cm (5½ x 7½ in) • British Museum, London

This ferocious scene is full of movement and the twisting and turning of bodies.
Leonardo enjoyed the creation of fantasy creatures, which are often terrifying in
their countenance and actions.

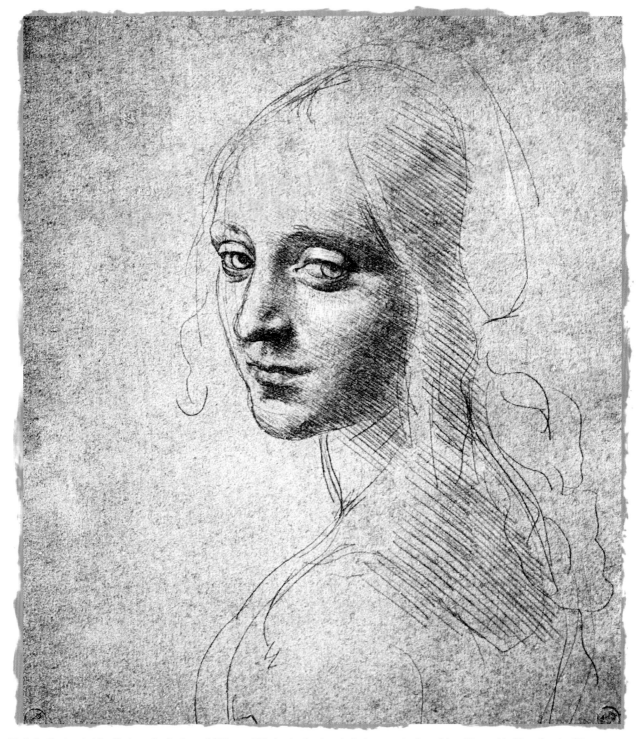

Study for the Angel of the Virgin on the Rocks, *c.* 1483
Silverpoint on paper, 18.1 x 15.9 cm (7 x 6¼ in)
• Biblioteca Reale, Turin

This drawing has been hailed as a masterpiece of draughtsmanship. The soft and subtle shadowing on the face and the lightest of suggestions for the flowing hair create an image of delicate and almost fragile beauty.

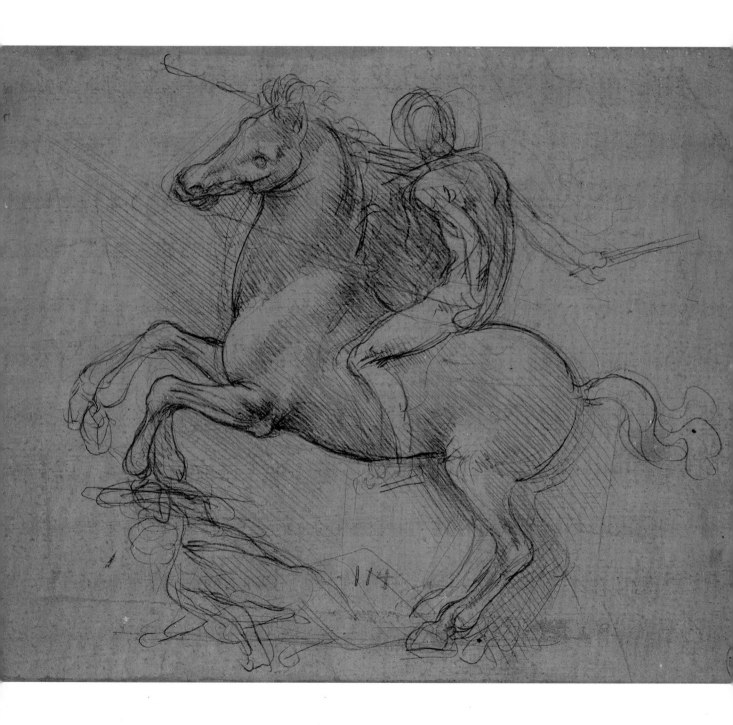

A Study for an Equestrian Monument, 1485–90
Metalpoint on paper, 15.2 x 18.8 cm (6 x 7½ in)
• Royal Collection Trust, Windsor Castle, London

Leonardo experimented with many designs for the projects he was involved with to create equestrian monuments. Here the horse rears up over a soldier who cowers before him on the ground.

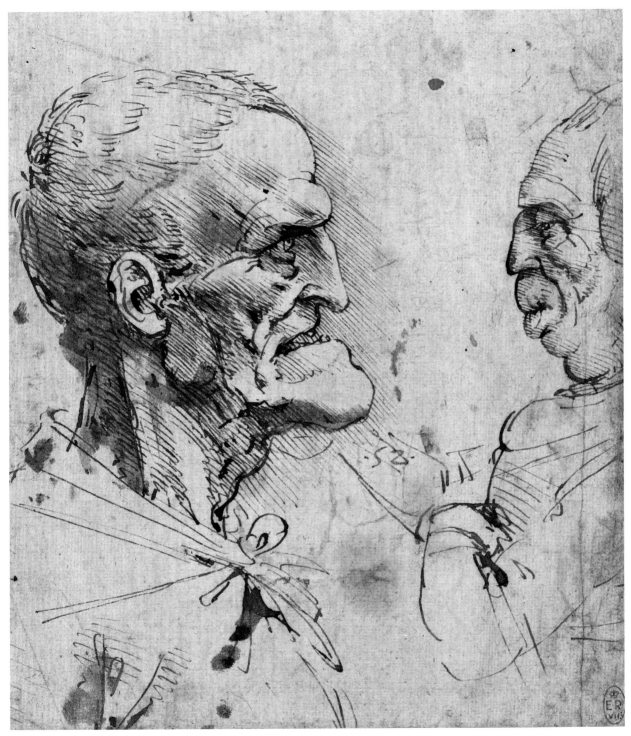

Two Grotesque Profiles Confronted, *c.* 1485–91
Pen and ink and wash on paper, 16.3 x 14.3 cm (6½ x 5 in)
• Royal Collection Trust, Windsor Castle, London

As well as focusing on physical appearance, Leonardo captured the expressive details of
a person's face. Here the careful play of light and the deft use of shadow in the two faces
highlight facial expression as well as physical attributes.

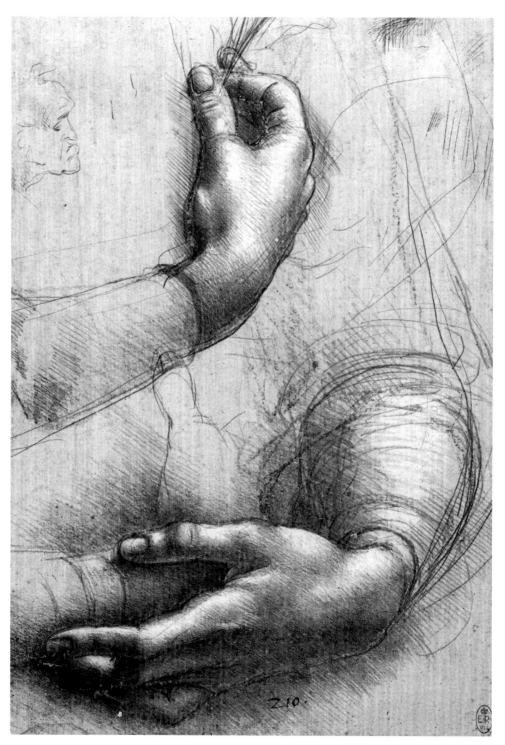

A Study of a Woman's Hands, *c.* **1490**
Metalpoint and charcoal on paper, 21.5 x 15 cm (8 x 6 in)
• Royal Collection Trust, Windsor Castle, London

The delicate and expressive positioning of this woman's hands creates flowing lines and gentle rhythms. It is thought that this may be a preliminary study for the hands in the portrait of Ginevra de' Benci, which were cut off the painting at some point.

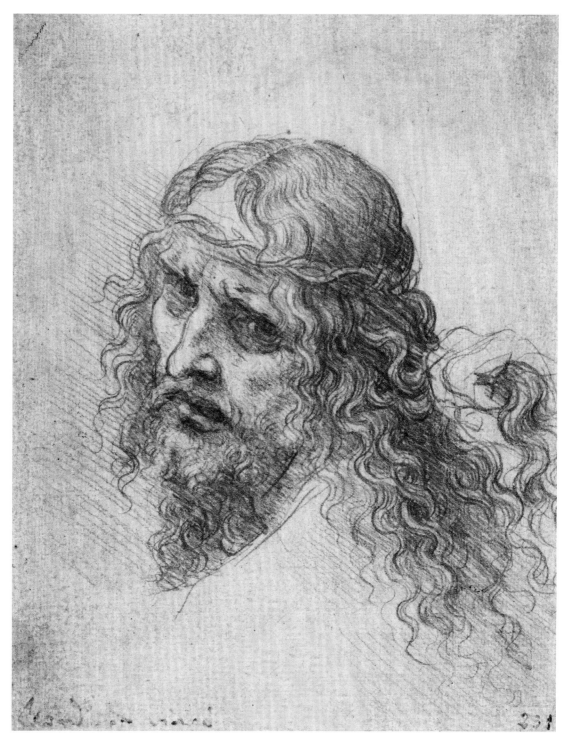

Head of Christ with a Hand Grasping his Hair, 1490–95
Black chalk on linen, 15.3 x 14.2 cm (6 x 5½ in)
• Gallerie dell'Accademia, Venice

With deep and dark shadowing around the eyes, nose and mouth of Christ, Leonardo expresses the anguish and pain of his suffering, not just physically but also mentally and emotionally.

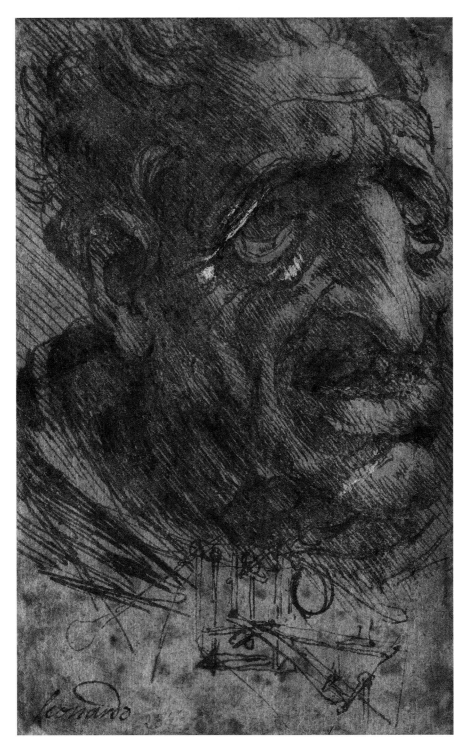

**Head of an Old Man and Sketches of a
Mechanical Device, 1490–99**
Pen and fine brush with sepia, 11.2 x 7.5 cm (4½ x 3 in)
• Gallerie dell'Accademia, Venice

The anguish of old age is movingly expressed in this emotional image. Leonardo's
mind would move rapidly from one topic to the next and there is often, as here, a
juxtaposition of contrasting thoughts on the same page.

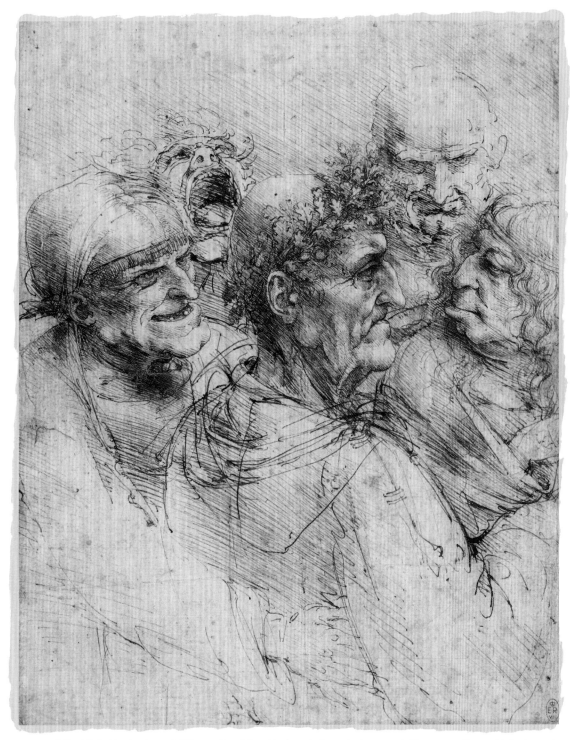

A Man Tricked by Gypsies, *c.* 1493
Pen and ink on paper, 26 x 20.5 cm (10 x 8 in)
• Royal Collection Trust, Windsor Castle, London

The distinguished man in the centre is surrounded by a group of Leonardo's 'grotesques' with exaggerated features, sly and devious expressions and unsettling behaviour.

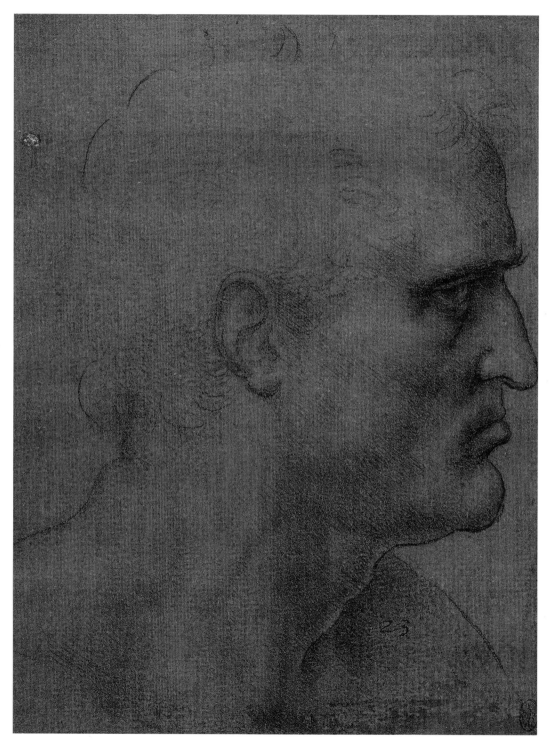

The Head of St Bartholomew, *c.* **1495**
Red chalk on pale red paper, 19.3 x 14.8 cm (7½ x 6 in)
• Royal Collection Trust, Windsor Castle, London

It is thought that this is a study for the head of St Bartholomew in *The Last Supper,* Leonardo's famous wall painting in Milan. Leonardo started a trend in artistic circles of using red chalk.

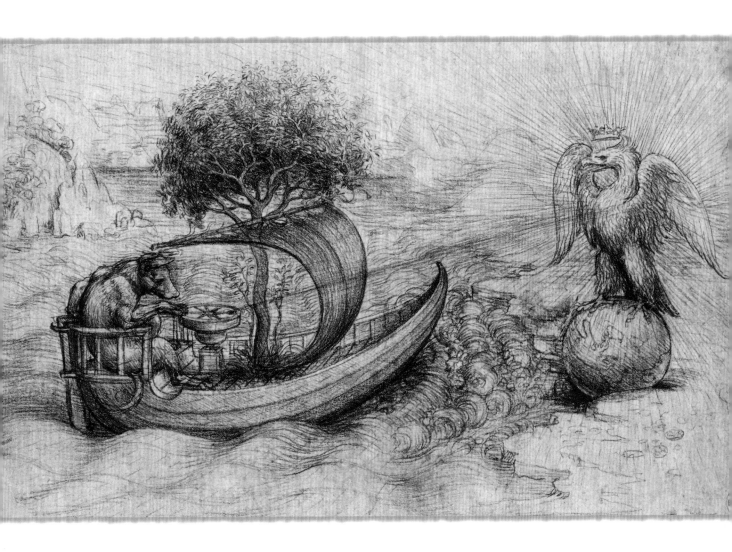

A Political Allegory, *c.* **1495**
Red chalk on paper, 17 x 28 cm (6½ x 11 in)
• Royal Collection Trust, Windsor Castle, London

Puzzles and allegories amused and intrigued Leonardo. Here it has been suggested that the eagle wears a French crown and the wolf in the boat represents the Pope steering the ship of the Church.

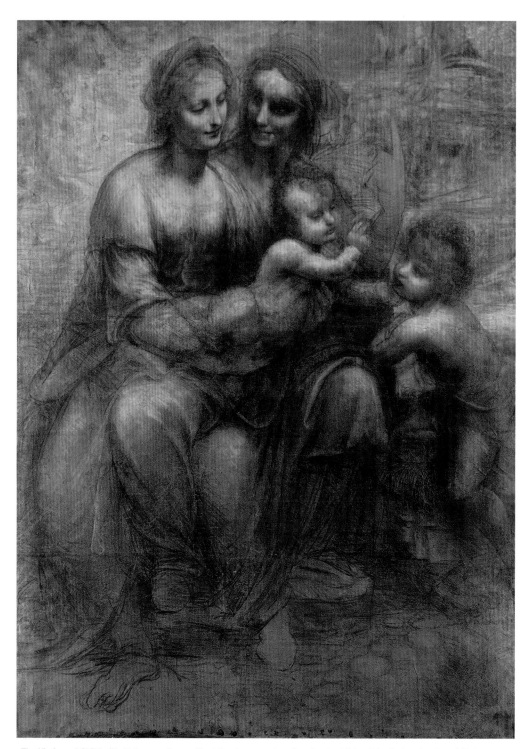

**The Virgin and Child with St Anne and
the Infant St John the Baptist, 1499–1500**
Charcoal and chalk on paper, 141.5 x 104.6 cm (55 x 41 in)
• National Gallery, London

The intimate expression of mother to child and the lively animation of Christ,
as he leans towards the infant John the Baptist, create harmony, unity and
a fluid, rhythmic line in this acclaimed preparatory drawing.

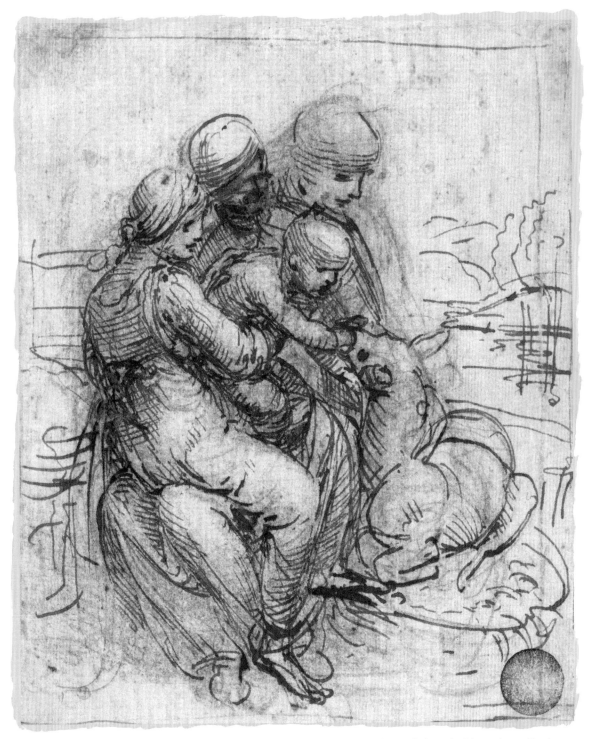

Virgin and Child with St Anne, c. 1501–10
Pen and ink on paper, 15.3 x 14.2 cm (6 x 5½ in)
• Gallerie dell'Accademia, Venice

The work is freely executed, appearing almost to be improvised. Leonardo considered that a preliminary sketch should be a stimulus to creative artistic invention and not appear too finished.

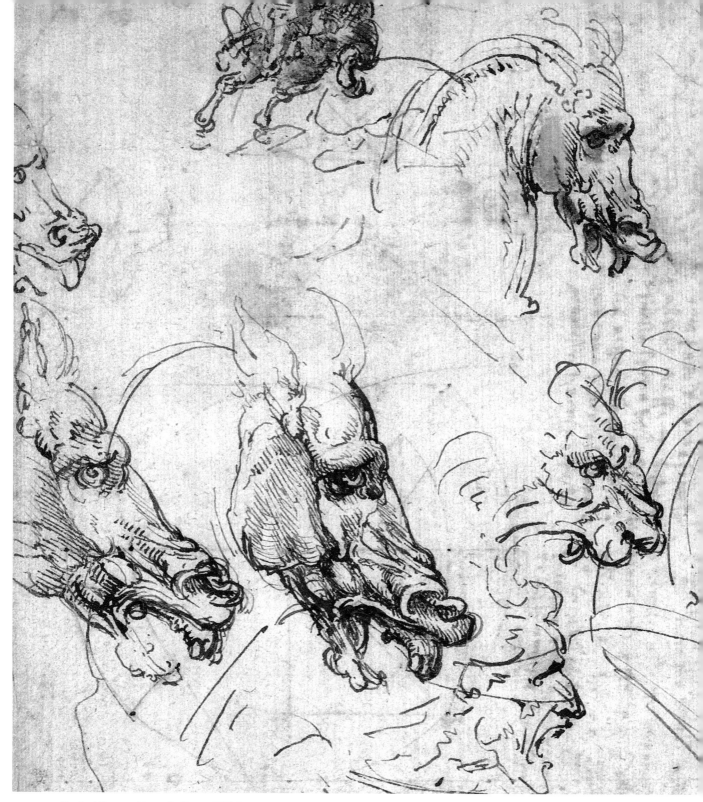

Heads of Horses, a Lion and a Man *c.* 1503–04
Pen and ink, wash and chalk on paper, 19.6 x 30.8 cm (7¾ x 12 in)
• Royal Collection Trust, Windsor Castle, London

These drawings form part of Leonardo's preparatory studies for *The Battle of Anghiari*. They focus on the representation of the horses' muscles as the bodies and heads twist and turn.

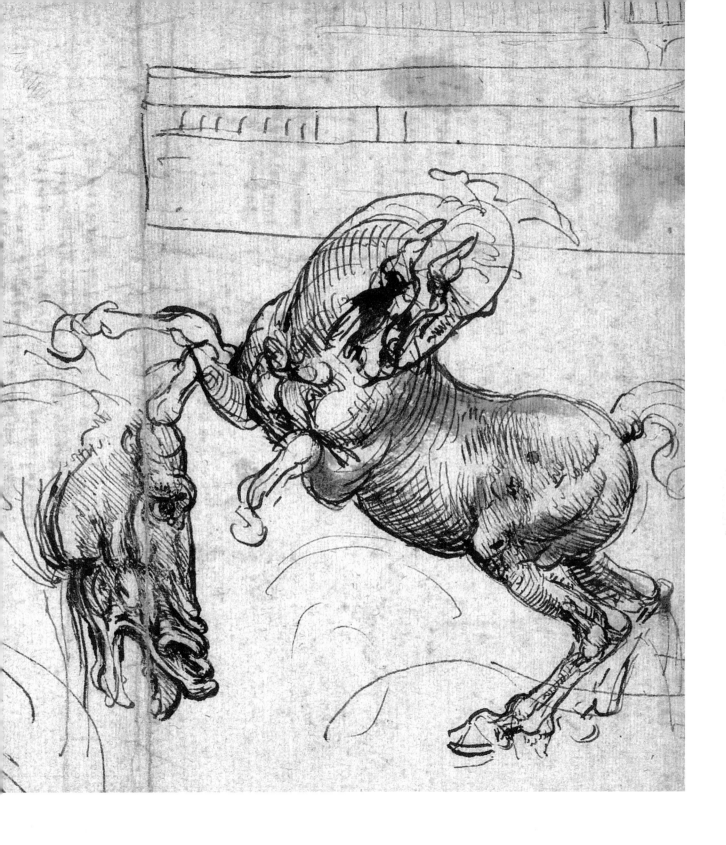

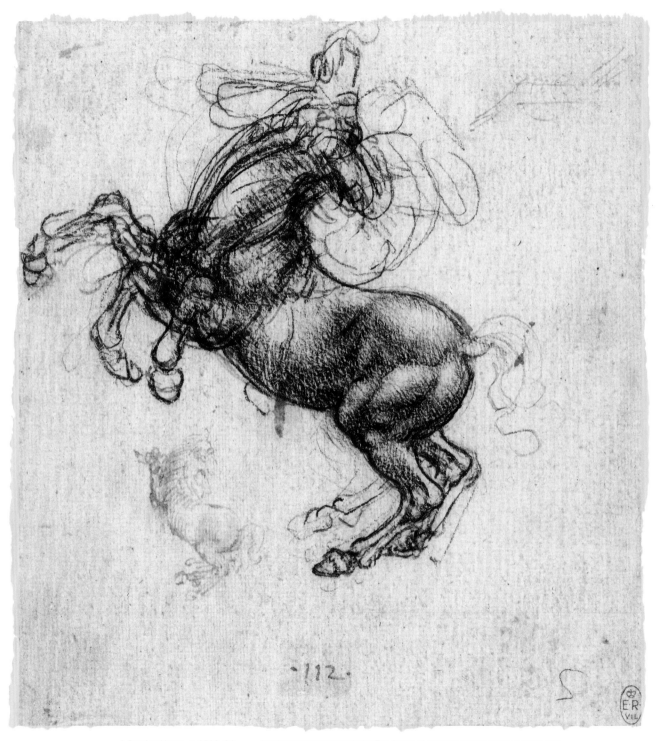

A Rearing Horse, *c.* 1503–04
Pen and ink and chalk on paper, 15.3 x 14.2 cm (6 x 5½ in)
• Royal Collection Trust, Windsor Castle, London

Another preparatory study for *The Battle of Anghiari*. Notice how Leonardo has experimented with a variety of positions for the horse's front and back legs.

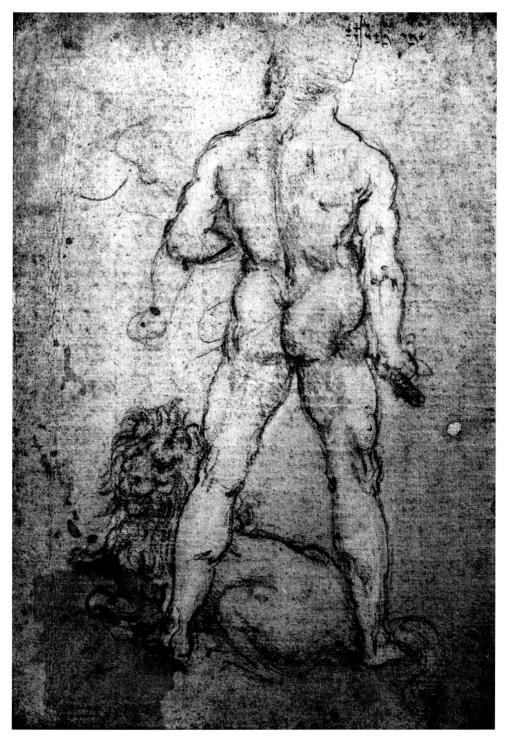

Hercules and the Nemean Lion, *c.* 1504
Pencil on paper, 15.3 x 14.2 cm (6 x 5½ in)
• Palazzo Reale, Turin

In Greek mythology the slaying of the ferocious lion at Nemea was a task given to Hercules by the King. This study has given Leonardo the opportunity to focus on the muscular structure of a man's body viewed from the back.

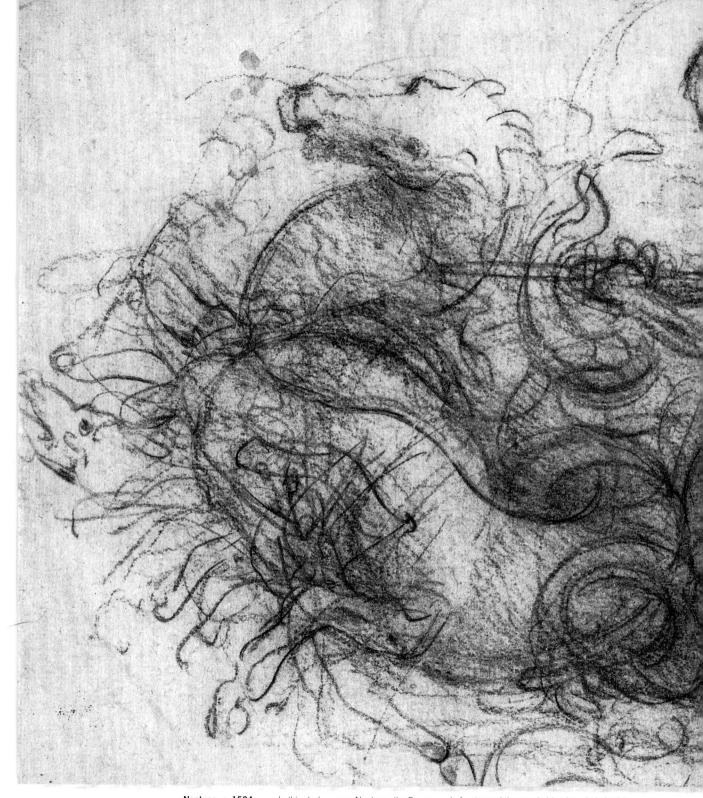

Neptune, c. 1504
Chalk on paper, 25.1 x 39.2 cm (10 x 15½ in)
• Royal Collection Trust, Windsor Castle, London

In this study we see Neptune, the Roman god of water and the sea, in his triumphal chariot of seahorses. The powerful and vigorous movements of the writhing horses create a fearful and commanding scene.

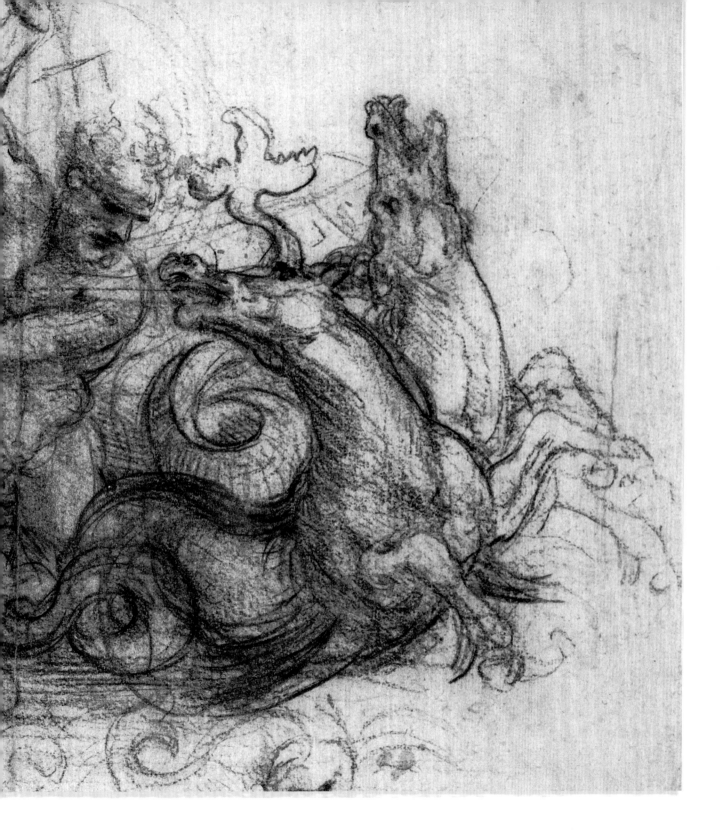

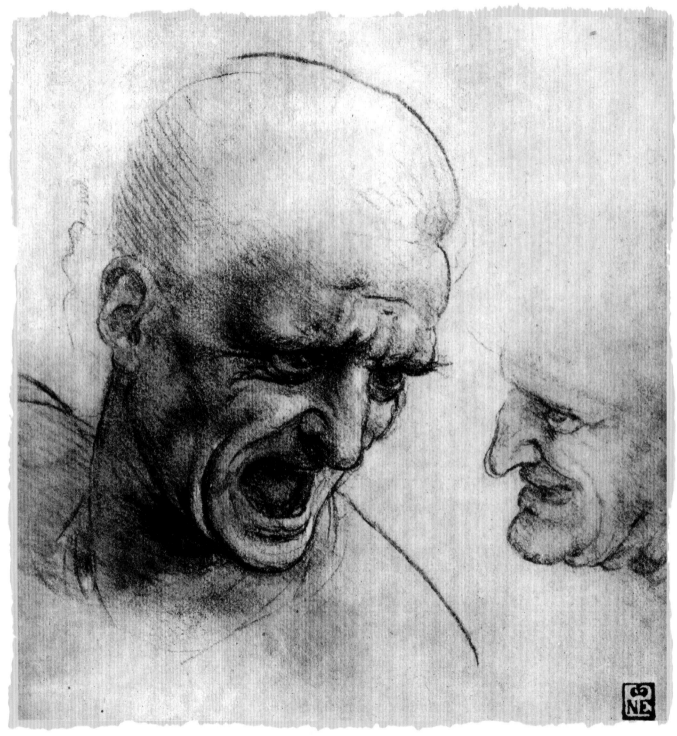

Study for a Warrior's Head, *c.* 1505
Black chalk on paper, 18.8 x 19.1 cm (7 x 7½ in)
• Museum of Fine Arts, Budapest

This is one of the many preparatory studies for *The Battle of Anghiari*. Leonardo has vividly captured the tense and threatening facial expression of a man under stress with his mouth wide open in the process of shouting.

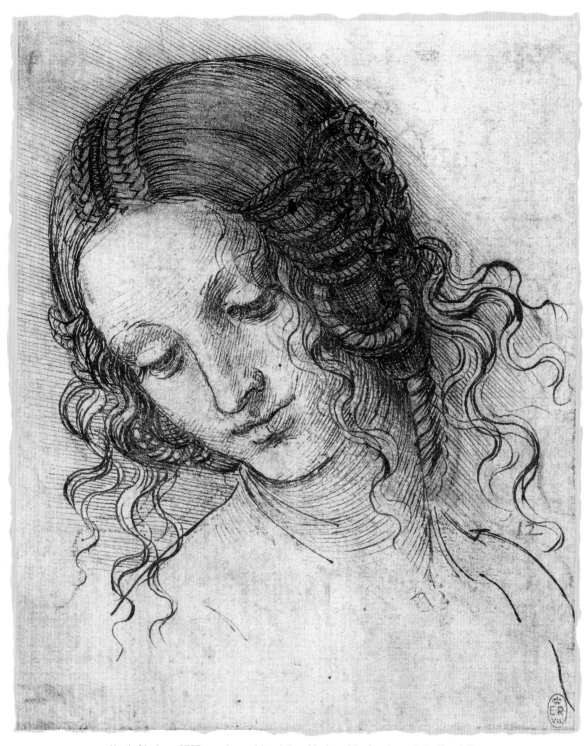

Head of Leda, *c.* 1505
Pen, ink and black chalk on paper, 17.7 x 14.7 cm (6½ x 5½ in)
• Royal Collection Trust, Windsor Castle, London

Leonardo's painting of *Leda and the Swan* is now lost, although it was
recorded in the estate of Salai in 1525. Leda's hair is braided in an intricate
and complex pattern.

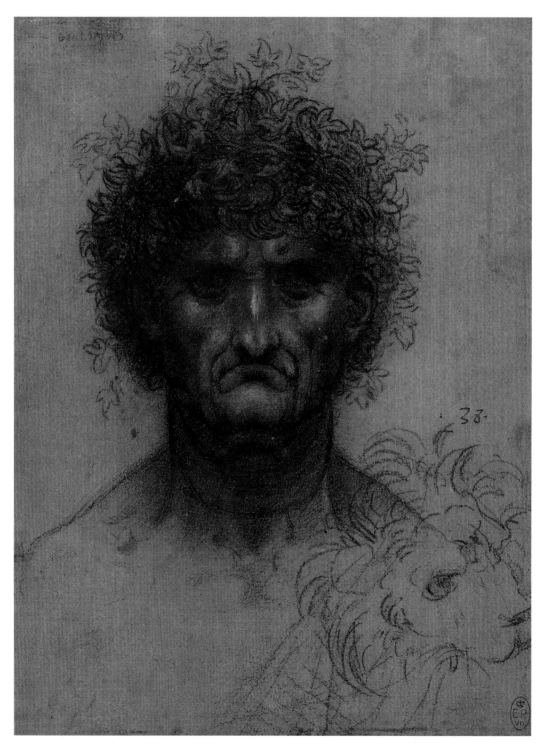

The Bust of a Man and the Head of a Lion, 1505–10
Chalk on paper, 18.3 x 13.6 cm (6¾ x 5 in)
• Royal Collection Trust, Windsor Castle, London

The character of this man's face is etched into every line and shade, and his hair is a riot of curls and wisps. Leonardo thought that the depiction of curls and wisps of hair should mimic the circular action of water.

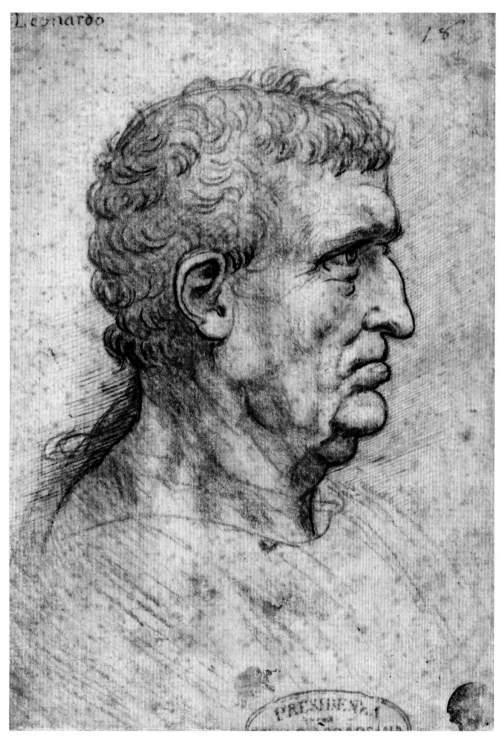

Head of a Man in Profile, 1506–08
Pencil and red chalk on paper, 11.7 x 5.2 cm (4½ x 2 in)
• Gallerie dell'Accademia, Venice

This is a meticulously drawn head, carefully noting the man's hair and outlining every wave and curl. The chin juts out and the line of the forehead and nose is pronounced.

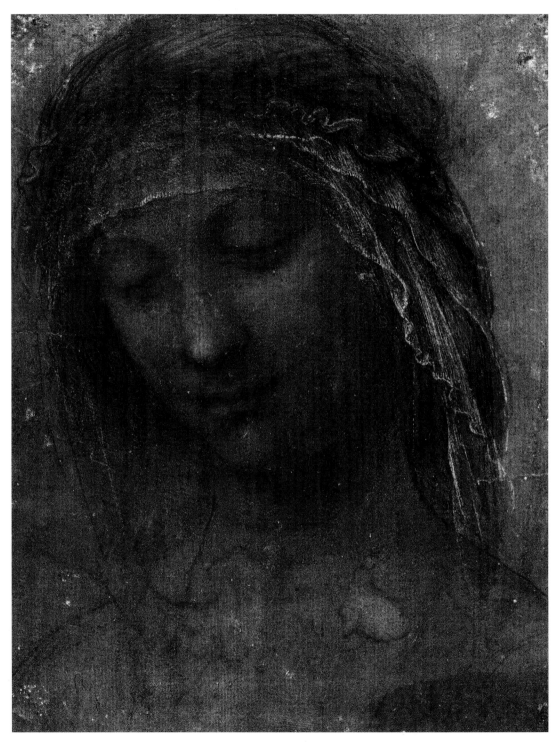

Head of the Madonna, *c.* **1510–15**
Chalk, ink and heightening on red paper, 24.4 x 18.7 cm (9½ x 7 in)
• Royal Collection Trust, Windsor Castle, London

The delicate diaphanous headdress is intimately traced around the Madonna's face and is an example of Leonardo's expressive style. However, it is thought that the rest of the work was probably done by a pupil.

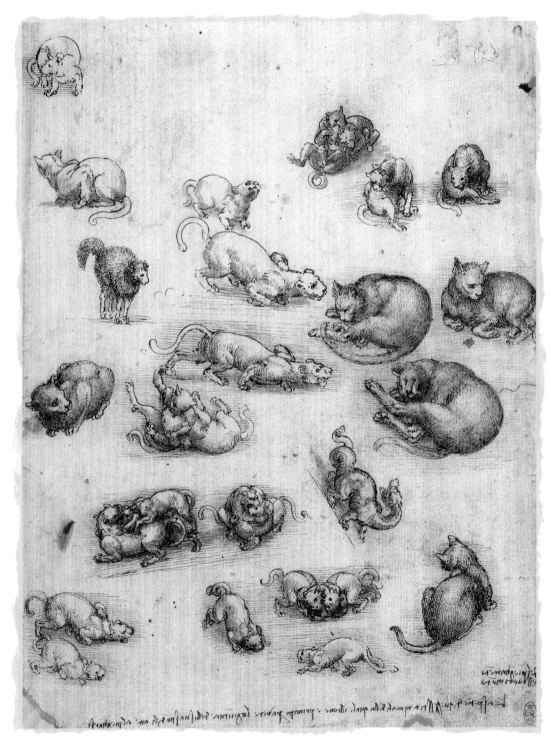

Cats, Lions and a Dragon, *c.* 1513–16
Pen and ink with wash over blue chalk, 27 x 21 cm (10½ x 8 in)
• Royal Collection Trust, Windsor Castle, London

This study may have been intended to form part of Leonardo's projected treatise on the nature of movement in animals. The creatures are depicted in a variety of positions.

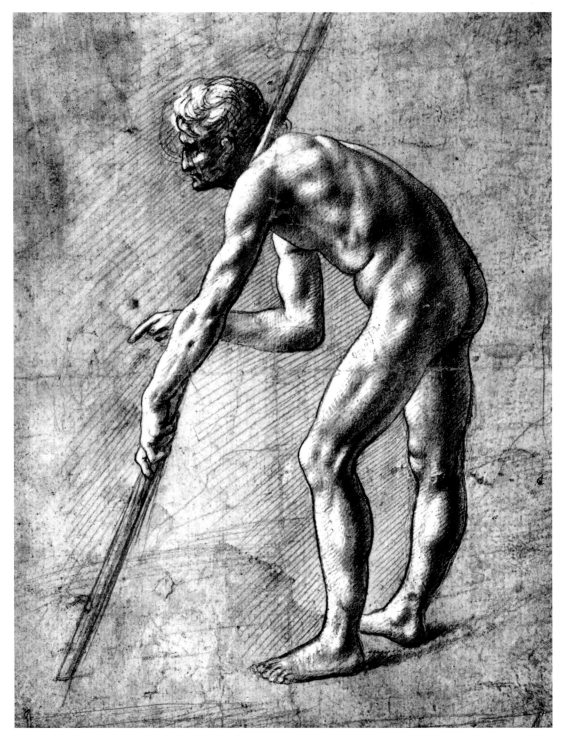

Study of a Man, *c.* 1517
Pencil on paper, 15.3 x 14.2 cm (6 x 5½ in)
• Royal Palace of Turin, Turin

This is a study of a stooped man who seems to need the support of a staff. The muscularity of the body is pronounced, which may be an indication of involvement in physical labour.

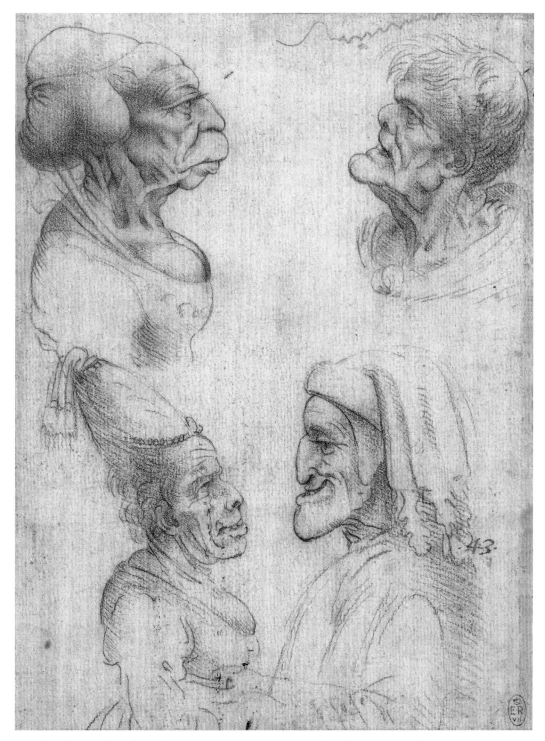

**Four Grotesque Heads, including a
Caricature of Dante, c. 1517–20**
Chalk on paper, 19.5 x 14.6 cm (7¾ x 5½ in)
• Royal Collection Trust, Windsor Castle, London

Here the artist has exaggerated facial features to create distorted and grotesque
parodies. The parody of Dante can be seen in the lower right corner gazing at Beatrice.
Leonardo seems to have enjoyed the challenge of making caricatures of people.

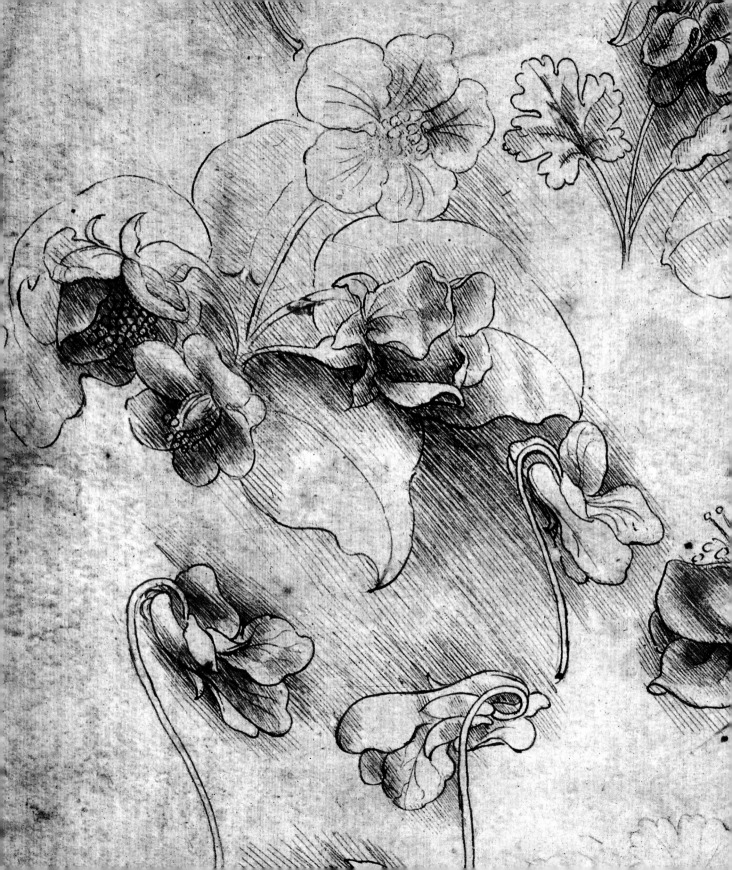

The Natural World

Leonardo was fascinated with the world around him and studied it in minute detail. His drawings of the human body, animals and plants are a synthesis of science and aesthetic beauty.

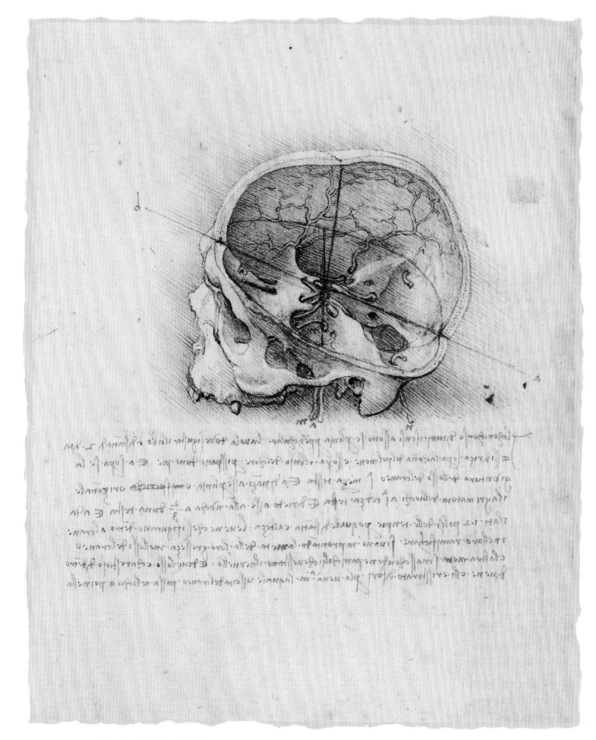

A Cranium Sectioned, 1489
Pen and ink over black chalk on paper, 19 x 13.7 cm (7½ x 5 in)
• Royal Collection Trust, Windsor Castle, London

Leonardo has here created a scientific drawing with an artist's creative and aesthetic skill. The study, based on direct observation, is precise and is annotated with in his characteristic mirror writing.

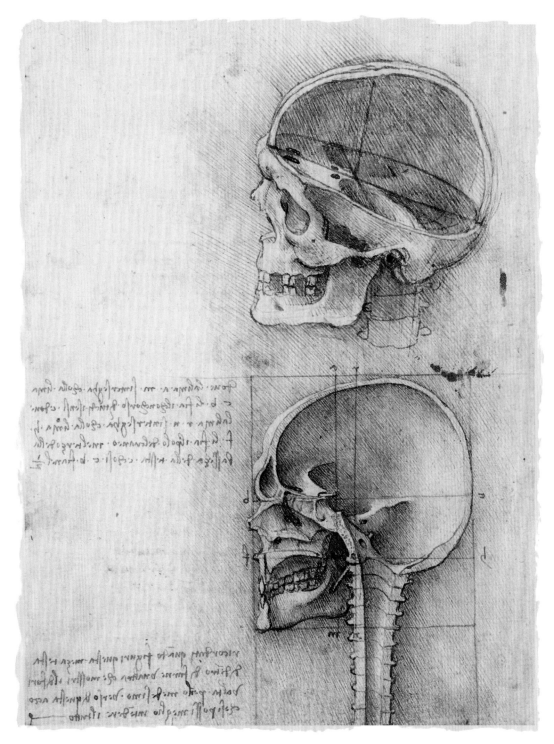

A Skull Sectioned, 1489
Pen and ink over black chalk on paper, 18.8 x 13.4 cm (7½ x 5 in)
• Royal Collection Trust, Windsor Castle, London

These two drawings of the skull, with accompanying explanatory notes, are seen from the left. The lower study has had squares drawn on it to aid in the accurate rendering of proportion.

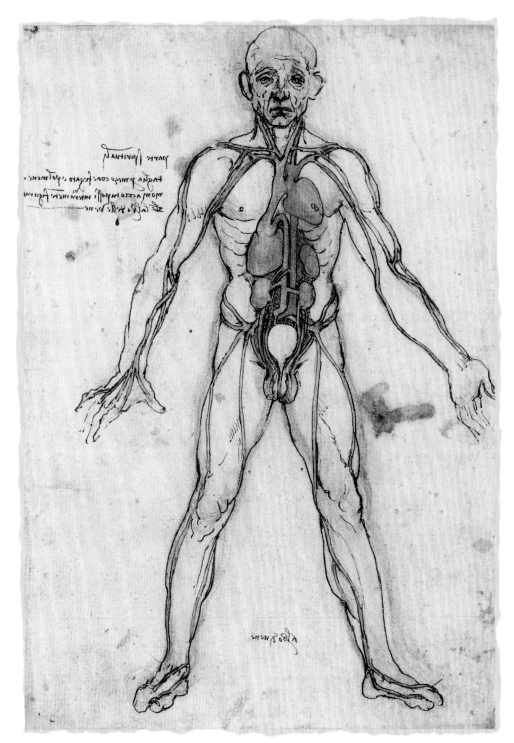

**A Male Anatomical Figure Showing the
Viscera and Principal Vessels, 1490**
Pen and ink with wash over, 28 x 19.8 cm (11 x 7¾ in)
• Royal Collection Trust, Windsor Castle, London

A full-length cross-section of a male body highlighting arteries and
main body organs, including the heart, kidneys and liver. No one else
would be close to Leonardo's accuracy in drawing the inside of the
body for centuries.

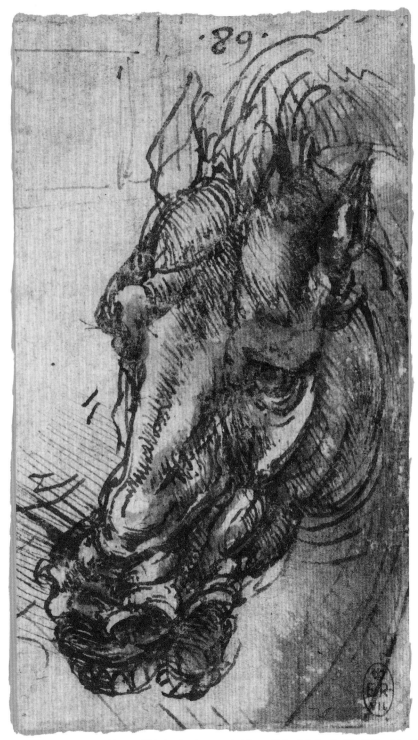

The Head of a Horse, 1503–04
Pen and ink with wash on paper, 11.1 x 6.3 cm (4 x 2½ in)
• Royal Collection Trust, Windsor Castle, London

This drawing forms part of the portfolio of studies for *The Battle of Anghiari*. It is part of the sheet that deals with a comparison of muscles in horses and humans.

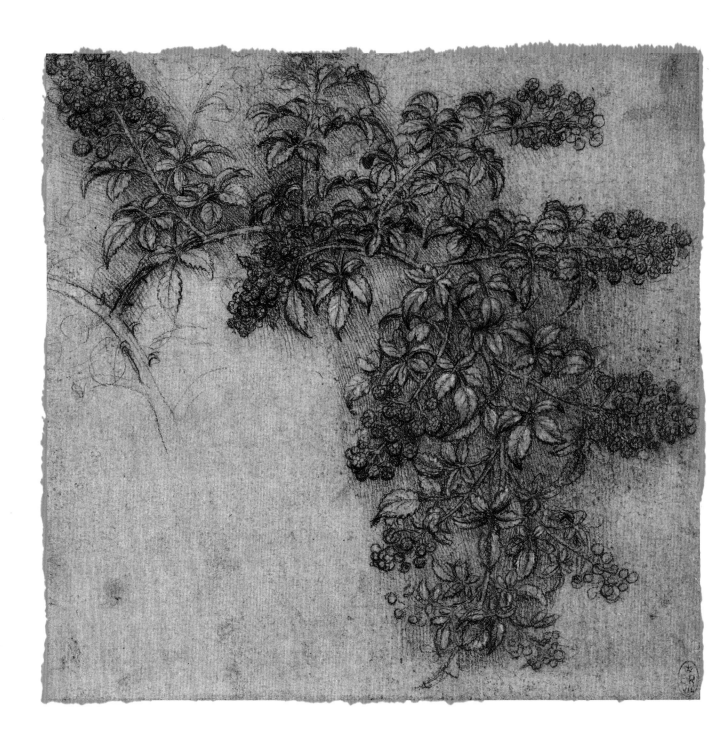

A Branch of Blackberry, 1505–10
Chalk and white heightening on paper, 15.5 x 16.2 cm (6 x 6 in)
• Royal Collection Trust, Windsor Castle, London

This botanical study highlights Leonardo's close and detailed observation of the plant world. This may have been a preparatory drawing for natural detail in the background of a painting.

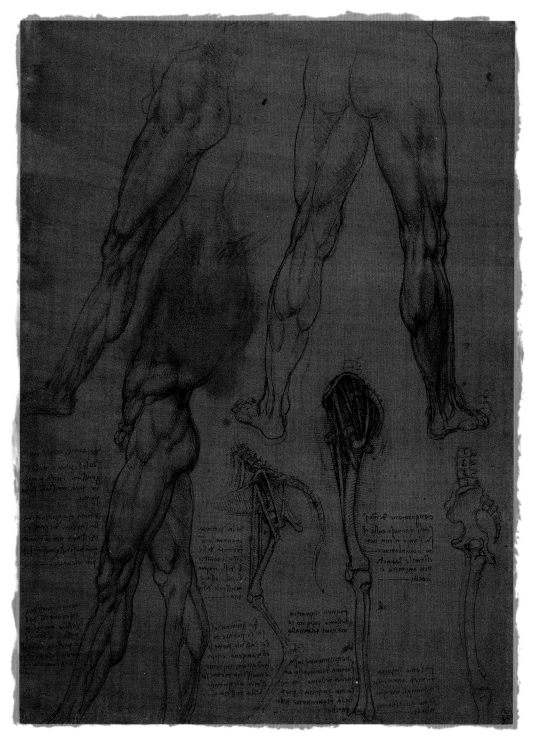

A Comparison of the Legs of a Man and of a Horse, 1506–10
Pen and ink with red chalk on paper, 28.2 x 20.4 cm (11 x 8 in)
• Royal Collection Trust, Windsor Castle, London

This drawing focuses on the internal skeletal structure of the leg and the external depiction of leg muscles. Leonardo worked with Marcantonio della Torre (1481–1511), a university doctor of anatomy, on his anatomical research.

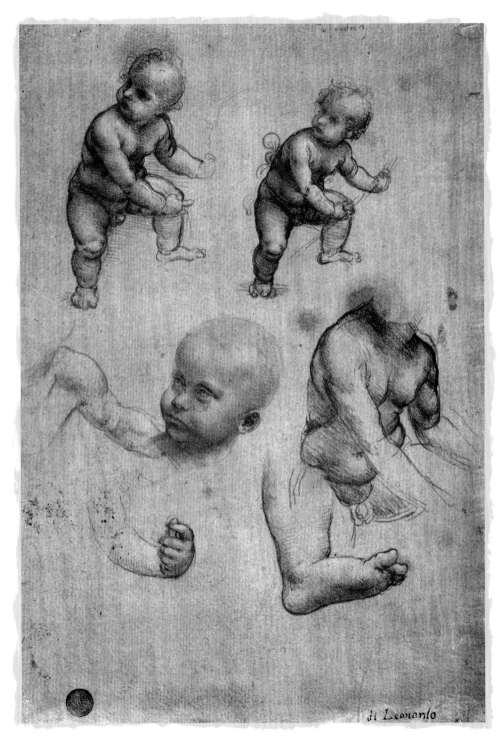

Study for the Infant Christ, 1508
Red chalk on paper, 17.7 x 14.7 cm (6½ x 5½ in)
• Gallerie dell'Accademia, Venice

It is thought that this drawing is a preparatory study for *The Virgin and Child with Saint Anne*. The lifting of the leg is clearly an aspect with which Leonardo is experimenting here.

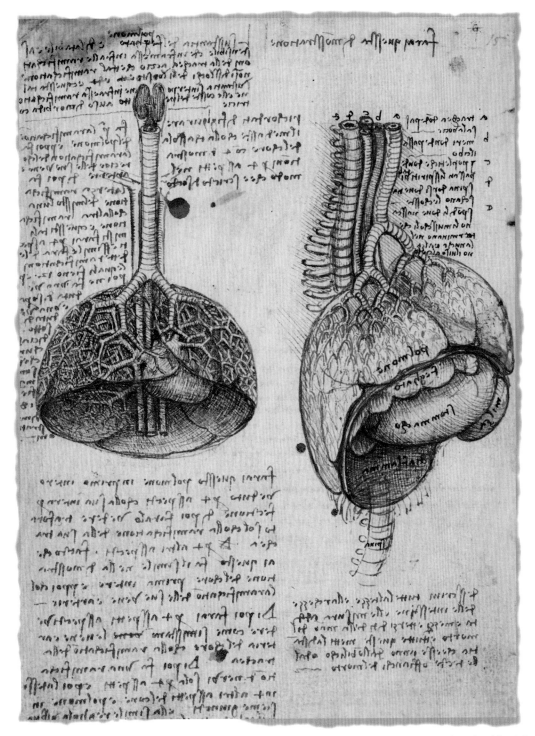

Study of the Thoracic and Abdominal Organs, 1508
Pen and ink over chalk on paper, 19.4 x 14.2 cm (7½ x 5½ in)
• Royal Collection Trust, Windsor Castle, London

In the right-hand drawing the thoracic and abdominal organs are shown in relation to the spinal column. On the left, the study shows the structure of the lungs. Both studies are thought to refer to a pig.

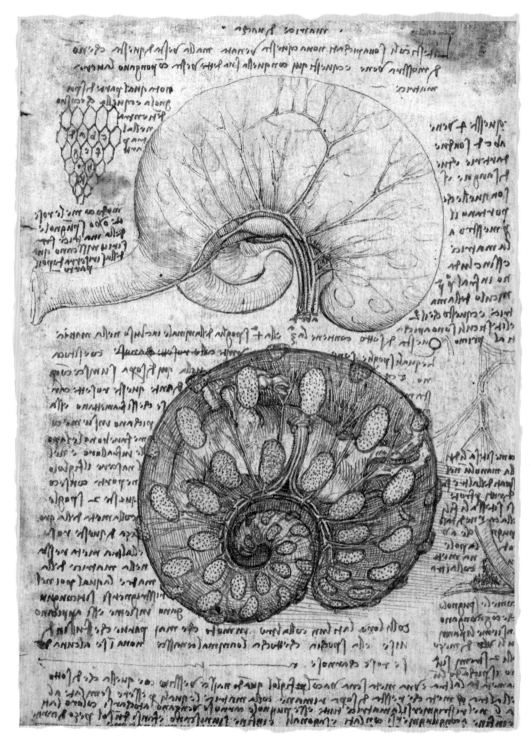

The Uterus of a Gravid Cow, 1508–09
Pen and ink over chalk, 19.2 x 14.2 cm (7½ x 5½ in)
• Royal Collection Trust, Windsor Castle, London

These two studies deal with the insides of a pregnant cow. Leonardo respected the animal world and spoke out forcibly about cruelty to animals, which he found abhorrent.

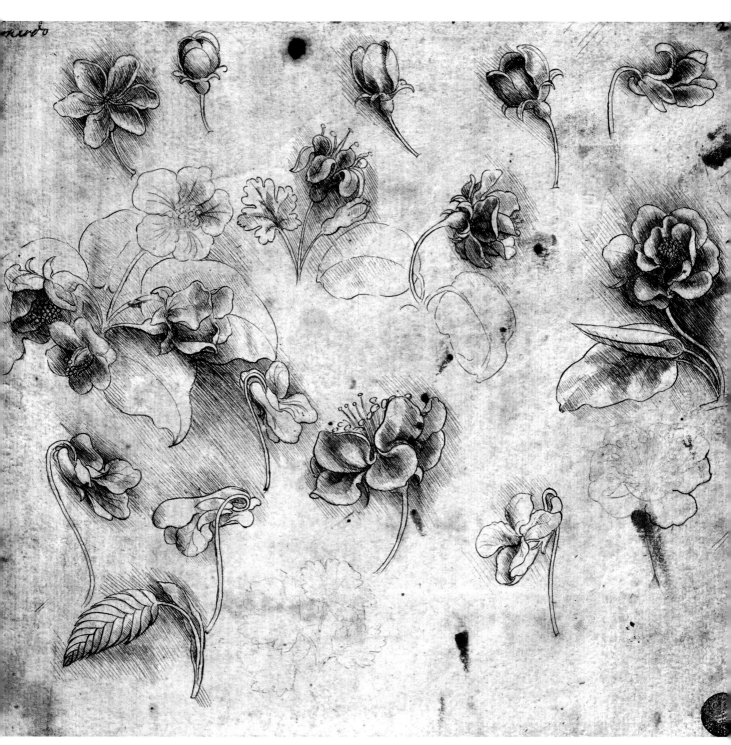

Botanical Table, c. 1510
Pen and ink on paper, 15.5 x 16.2 cm (6 x 6 in)
• Gallerie dell'Accademia, Venice

This beautiful study of various aspects of leaves and flowers, at different stages of their life cycles, displays the free-flowing curves and the sense of circular movement characteristic of Leonardo's work.

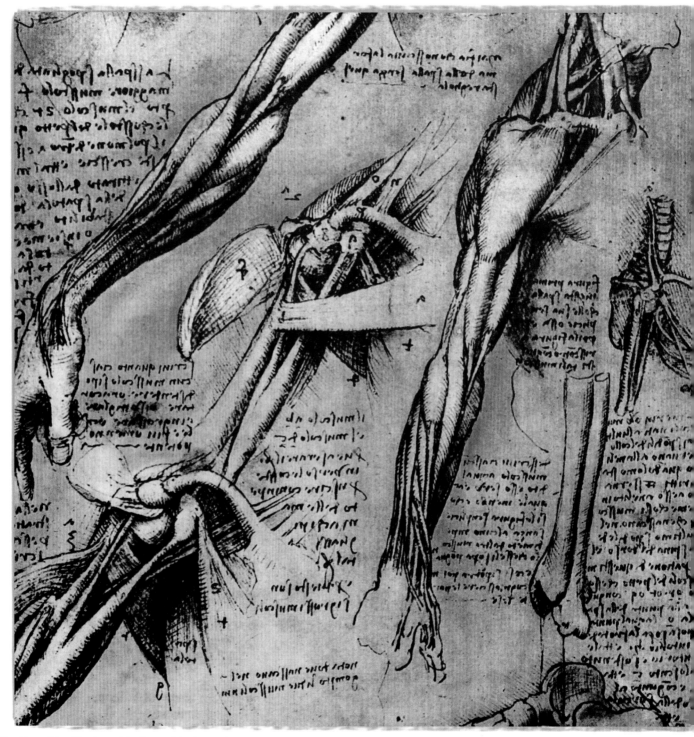

Shoulder and Arm Muscles and the Bones of the Foot, c. 1510
Pen and ink with wash over black chalk on paper, 28.9 x 20.1 cm (11 x 8 in)
• Royal Collection Trust, Windsor Castle, London

These studies show the inter-relationships between the muscles, joints and
bones of the shoulder, arm and foot, how they are attached to each other
and how they function.

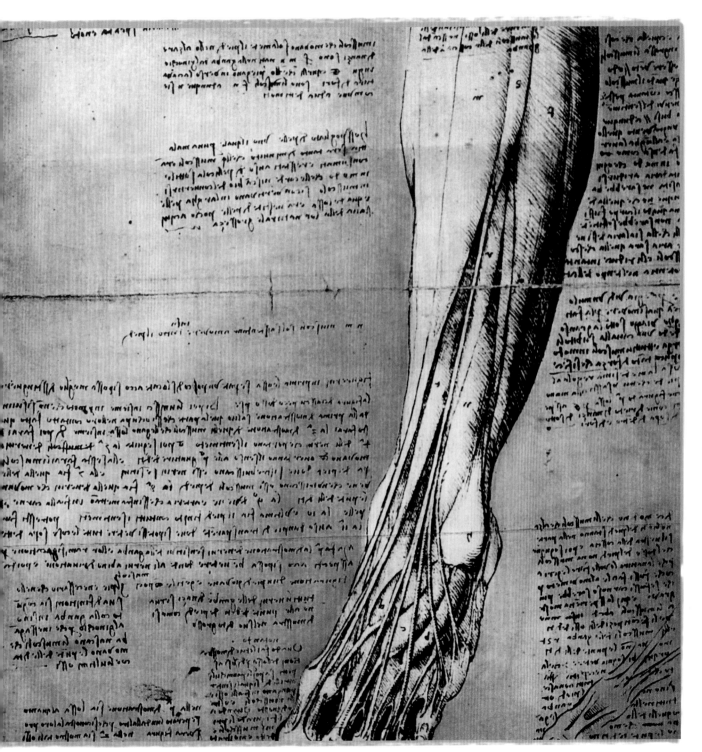

This image makes extensive use of Leonardo da Vinci's 'mirror writing'.

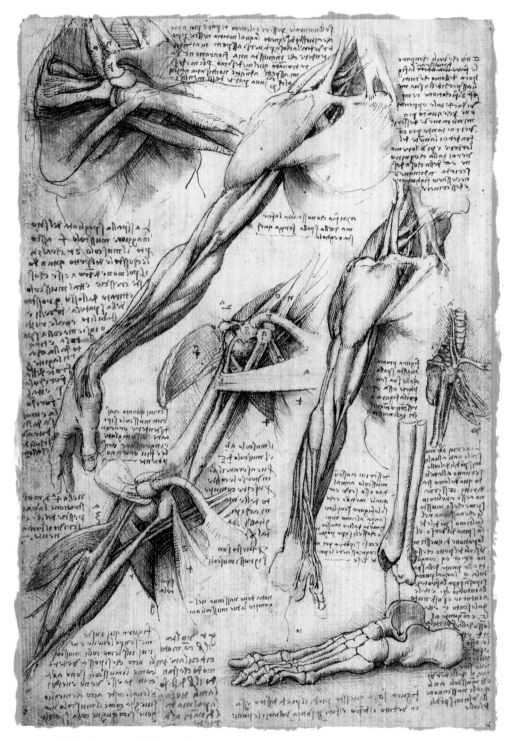

Muscle Structure, *c.* 1510
Pen and ink on paper, 28 x 19.8 cm (11 x 7¾ in)
• Science and Technology Museum, Milan

The muscle structure of the leg is exposed and can be compared to the muscle
structure of the arm and the foot. The studies are surrounded by copious explanatory
notes in Leonardo's mirrored writing.

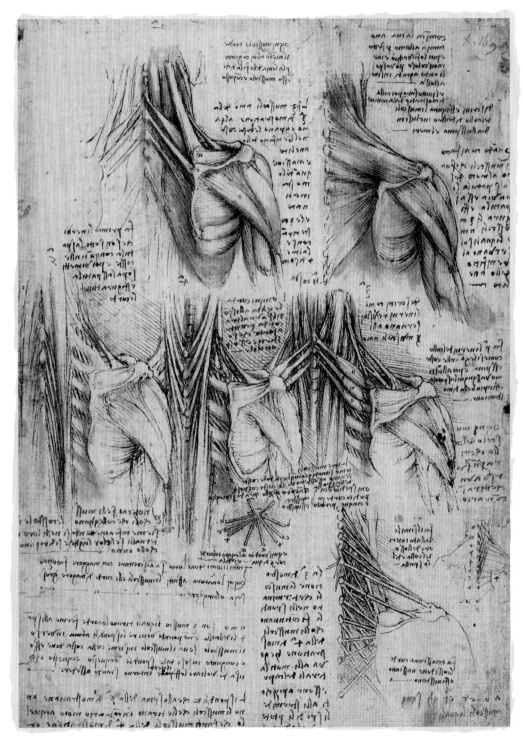

The Muscles of the Upper Spine, *c.* 1510

Pen, ink, wash and black chalk on paper, 28.9 x 20.5 cm (11½ x 8 in)
• Royal Collection Trust, Windsor Castle, London

Leonardo thought the human body was like a machine, but called it far superior and the most perfect machine in nature. He said muscles work like cables and joints are like hinges.

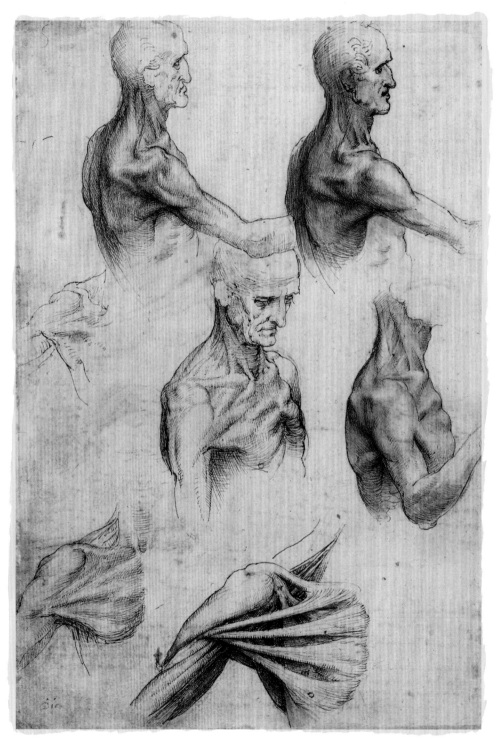

The Superficial Anatomy of the Shoulder and Neck, c. 1510
Pen and ink with wash over black chalk, 28.9 x 19.8 cm (11½ x 7¾ in)
• Royal Collection Trust, Windsor Castle, London

These studies show superficial muscles of the head, neck and thorax of a man. At the bottom of the page are two studies of a right-hand shoulder seen from the right.

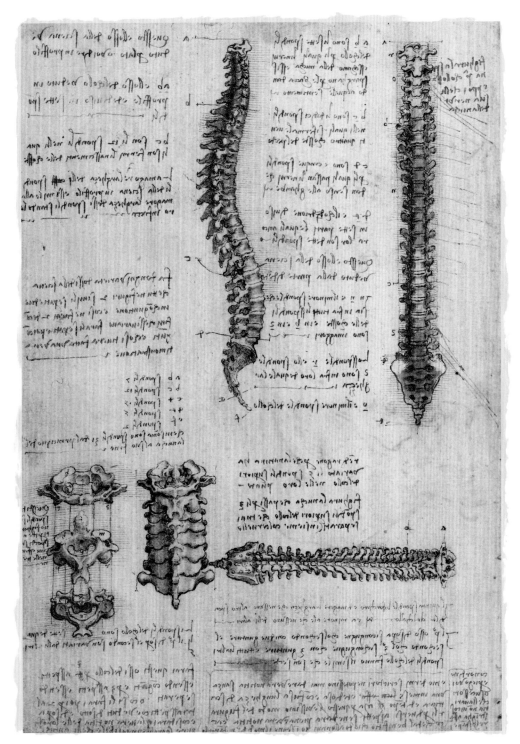

The Vertebral Column, c. 1510

Pen, ink and wash over traces of black chalk, 28.6 x 20 cm (11 x 8 in)
• Royal Collection Trust, Windsor Castle, London

Three studies of the vertebral column are shown here. One is a front view, another is a profile view and at the bottom is a view of a horizontally placed spine alongside detailed drawings of the vertebrae.

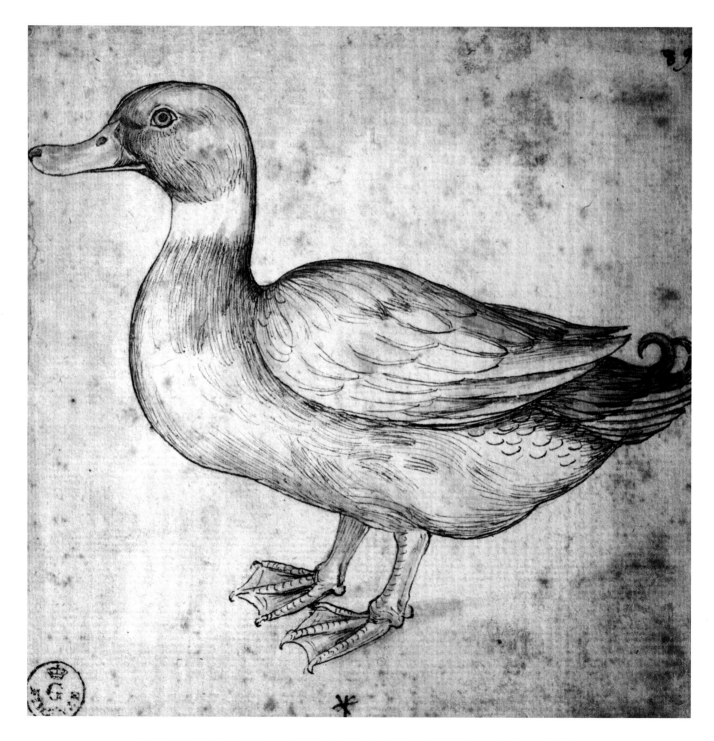

Animal Studies: Duck, *c.* 1510
Pen and ink on paper, 11.1 x 6.3 cm (4 x 2½ in)
• Galleria degli Uffizi, Florence

This charming study of a duck is meticulously observed and executed in this drawing. The two upward curls on the end tail feathers exhibit Leonardo's love of circular movement and flow.

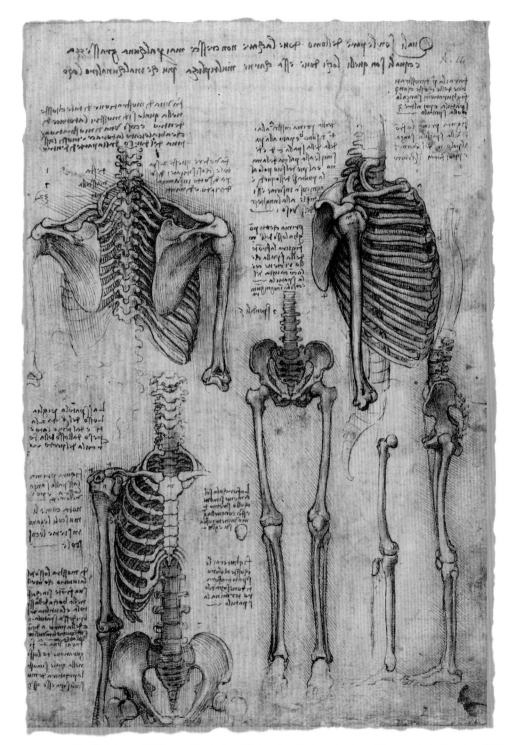

The Skeleton, *c.* 1510
Pen and ink over black chalk on paper, 28.8 x 20 cm (11½ x 8 in)
• Royal Collection Trust, Windsor Castle, London

The studies at the top show the bone structure of the upper body. These beautifully executed drawings of the human skeleton turn anatomical drawing into an art form.

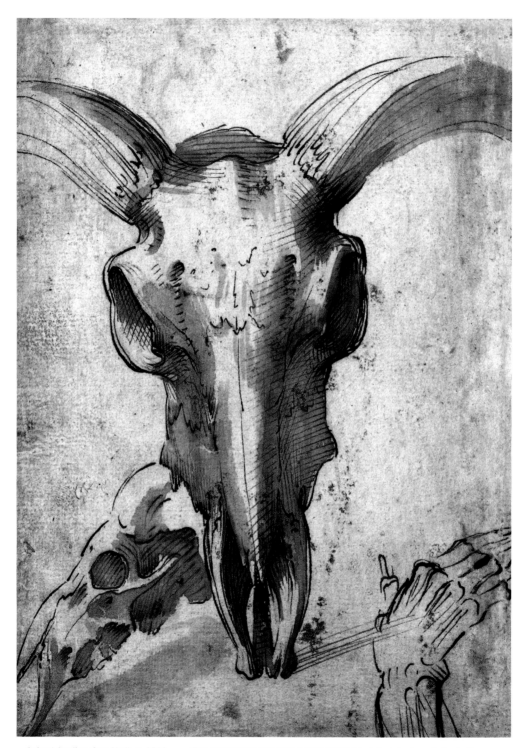

Animal Studies: Cow Skull, *c.* 1510
Pen and ink on paper, 11.1 x 6.3 cm (4 x 2½ in)
• *Galleria degli Uffizi, Florence*

This drawing of a cow skull is bold, striking and strongly characterized with a seemingly infinite variety of shading. What appears to be a human hand hovers at the bottom of the page.

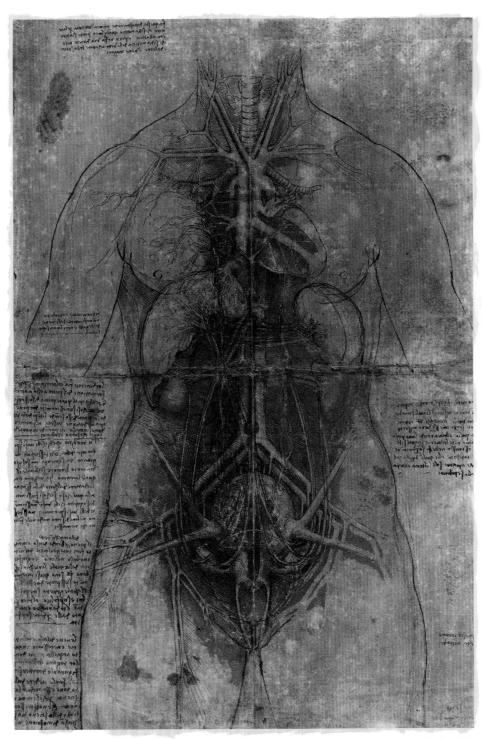

The Principal Organs and Vessels of a Woman, *c.* **1510**
Pen and ink with chalk and wash on paper, 47.6 x 33.2 cm (18¾ x 13 in)
• Royal Collection Trust, Windsor Castle, London

Leonardo was able to describe the organs of the human body in such detail due to his work dissecting dead bodies. This drawing describes the thorax, the abdomen and the vascular system of a woman.

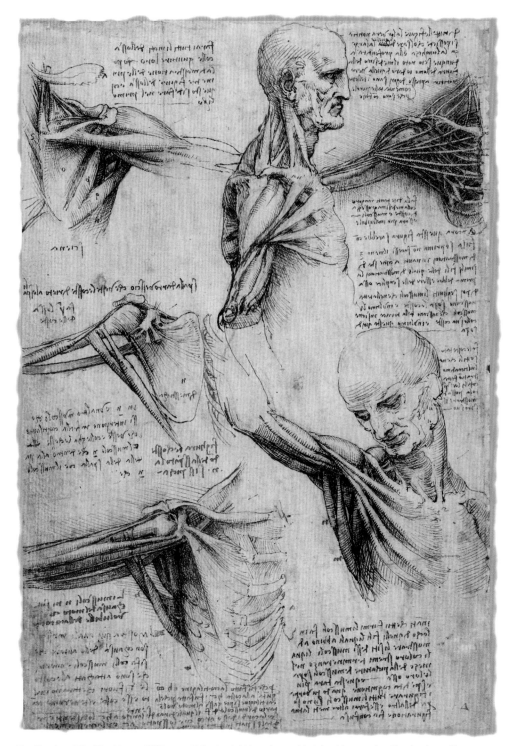

The Muscles of the Shoulder, *c.* 1510
Pen and ink over black chalk on paper, 29.2 x 19.8 cm (11½ x 7¾ in)
• Royal Collection Trust, Windsor Castle, London

At the top right is a wire model of shoulder muscles. The drawings with arms
extended enable a clearer version of the muscles of the chest, revealing
Leonardo's profound understanding of anatomy.

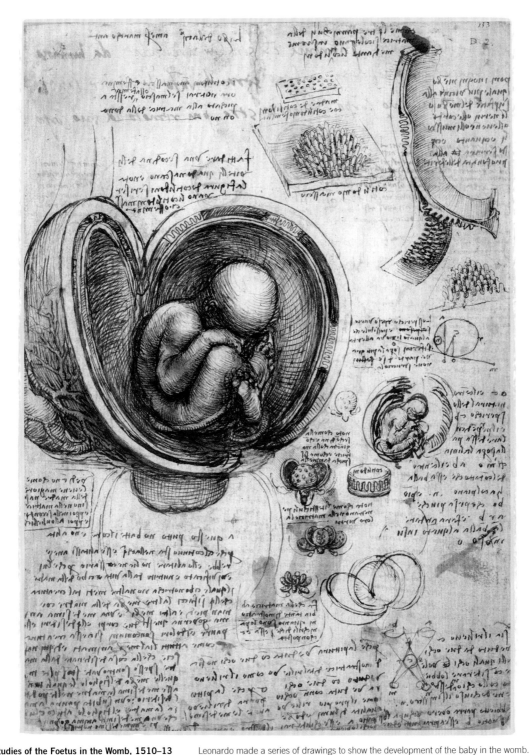

Studies of the Foetus in the Womb, 1510–13

Pen and ink with red and black chalks, 30.4 x 22 cm (12 x 8½ in)

• Royal Collection Trust, Royal Library, Windsor Castle

Leonardo made a series of drawings to show the development of the baby in the womb.
His notes state that the foetus in this drawing is around four months old and is 'surrounded
by dense, viscous water'.

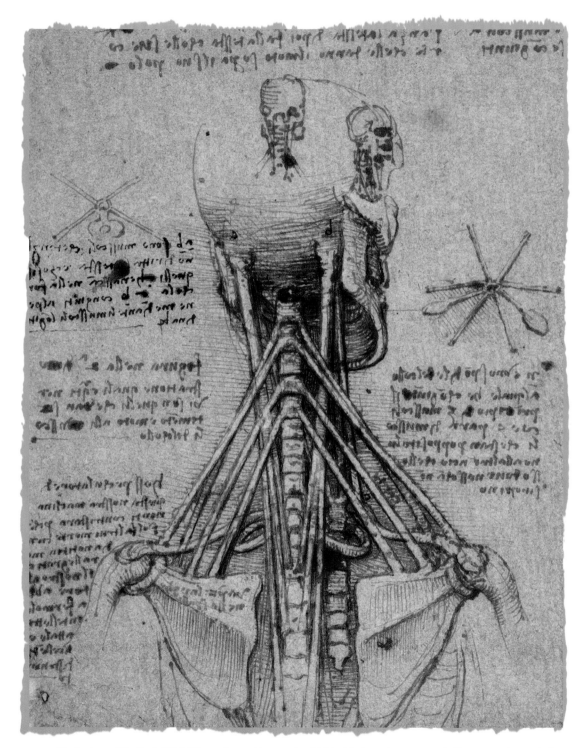

The Anatomy of the Neck, 1512–13
Pen and ink on blue paper, 27.6 x 20.7 cm (10¾ x 8 in)
• Royal Collection Trust, Windsor Castle, London

Leonardo's research established that muscles are connected to nerves and nerves to the brain. His drawing shows 'a tree of nerves descending from the brain ... which spreads throughout the spinal column'.

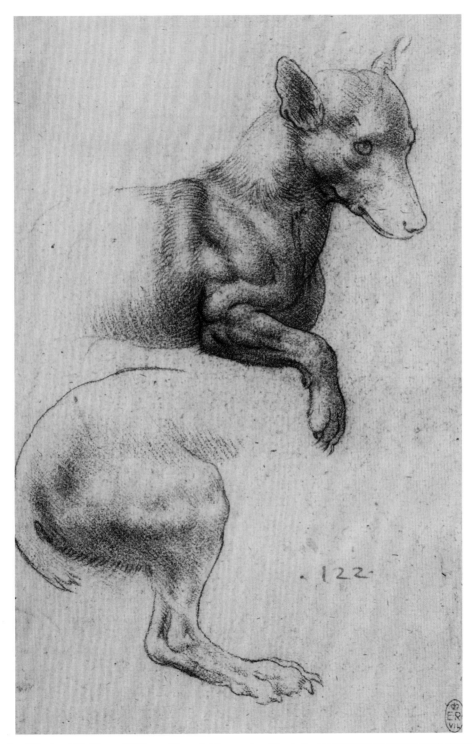

A Dog's Head and Chest and Hind-leg, *c.* 1520
Red chalk on paper, 18.5 x 12.1 cm (7 x 4¾ in)
• Royal Collection Trust, Windsor Castle, London

The underlying muscles of the dog's upper body and his paw are clearly shown. The careful rendering of the animal's fur is naturalistic and realistic, and his expression is winsome.

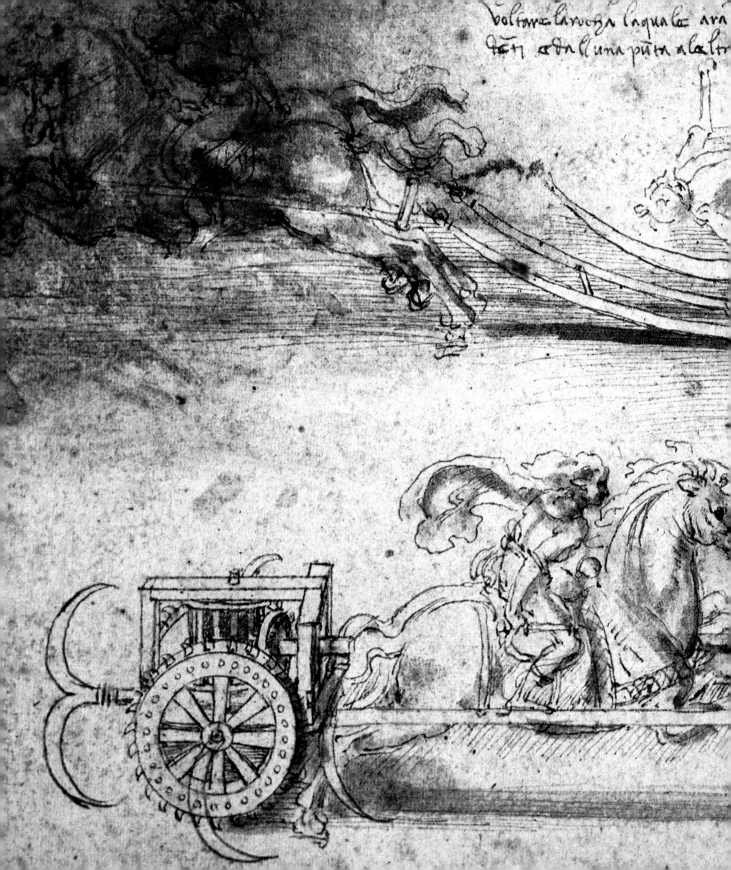

Inventions

Leonardo, as a student of engineering, physics, optics, anatomy, mathematics, astronomy and hydraulics, was as much a scientist as he was an artist. He envisaged machines centuries ahead of his time and his peerless skills as a draughtsman captured his designs for them on paper.

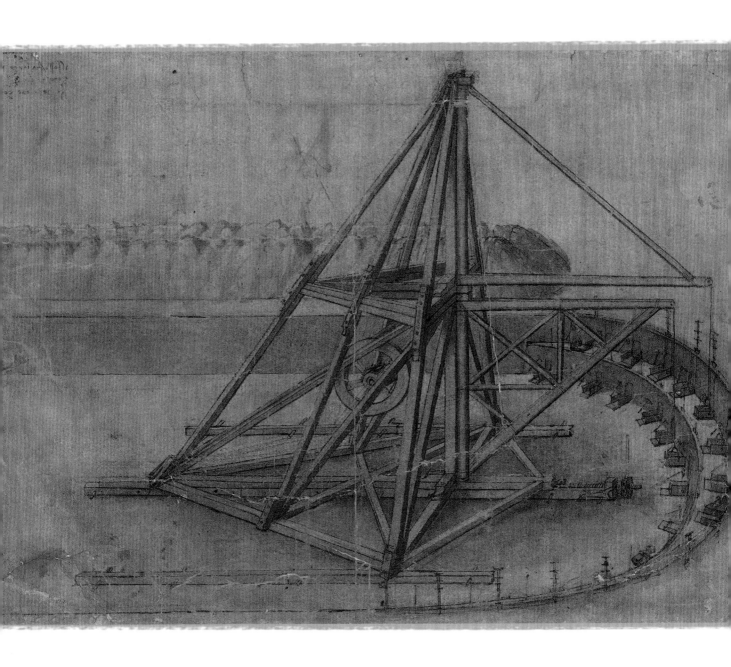

Crane, Excavator: Atlantic Codex, 1478–1519
Pencil on paper, 22 cm x 16 cm (8½ x 6 in)
• Biblioteca Ambrosiana, Milan

The Atlantic Codex contains many drawings related to engineering projects. This excavator may have been designed with a view to constructing canals, as Leonardo was involved in a number of canal construction projects.

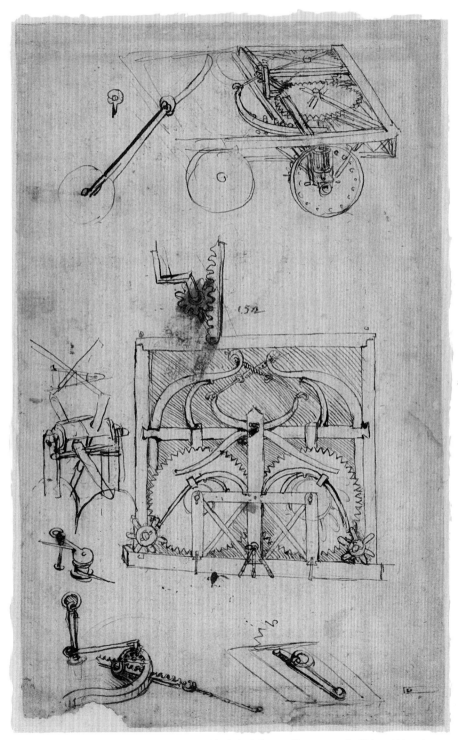

Self-moving Cart (also known as Leonardo's automobile): Atlantic Codex, 1478–1519
Pencil on paper, 22 cm x 16 cm (8½ x 6 in)
• Biblioteca Ambrosiana, Milan

This remarkable design is for a multi-purpose cart, which could have been used in an agricultural or warfare context. Modern reconstructions of the cart have been successfully created from Leonardo's diagrams.

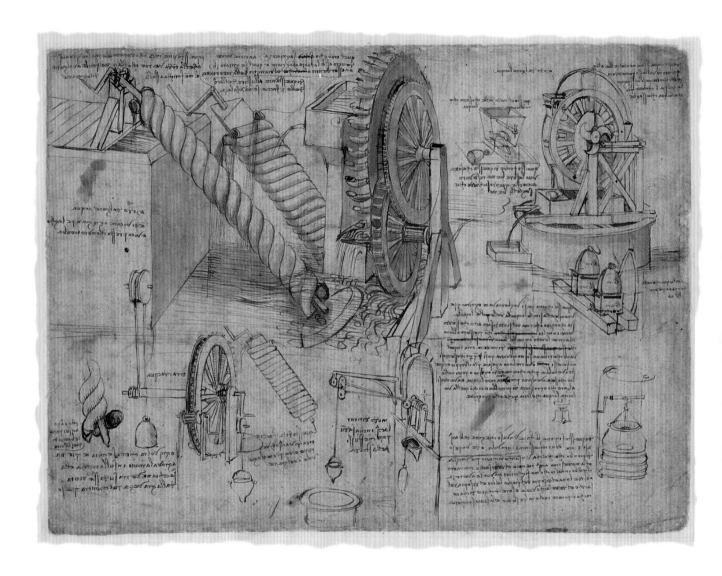

**Machines to Draw Water from a Well and Bring
it into Houses: Atlantic Codex, 1478–1519**
Pencil on paper, 22 cm x 16 cm (8½ x 6 in)
• Biblioteca Ambrosiana, Milan

Leonardo spent much time and effort planning projects that involved the
movement of water. Even as an apprentice he made the bold suggestion
of turning a section of the Arno River into a navigable canal.

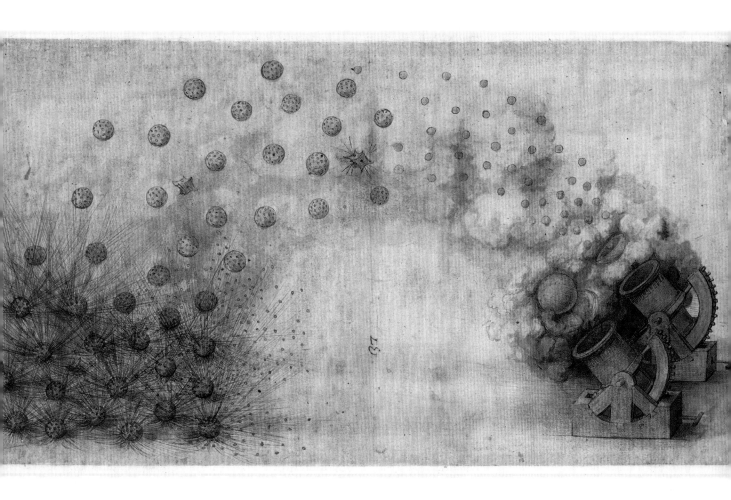

Study of Two Mortars for Throwing Explosive Bombs: Atlantic Codex, 1478–1519
Pencil on paper, 22 cm x 16 cm (8½ x 6 in)
• Biblioteca Ambrosiana, Milan

Leonardo was much in demand as a military engineer and spent many hours designing firearms. He was an original thinker but was also able to communicate through drawing the practical construction and functioning of his inventions.

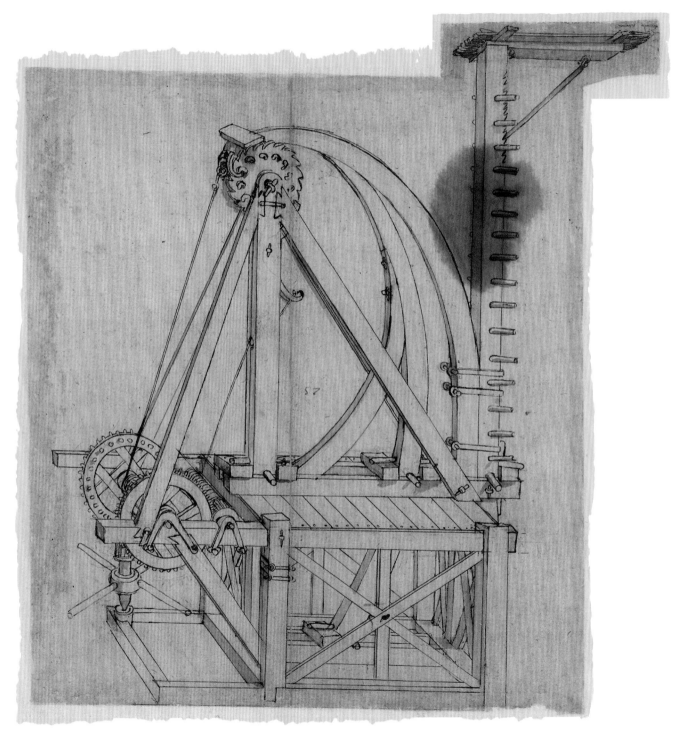

Catapult: Atlantic Codex, 1478–1519
Pencil on paper, 22 cm x 16 cm (8½ x 6 in)
• Biblioteca Ambrosiana, Milan

This giant catapult is drawn in detail and the drawing clearly shows the individual parts of the machine. Military defence was an important topic in Milan due to a possible French invasion.

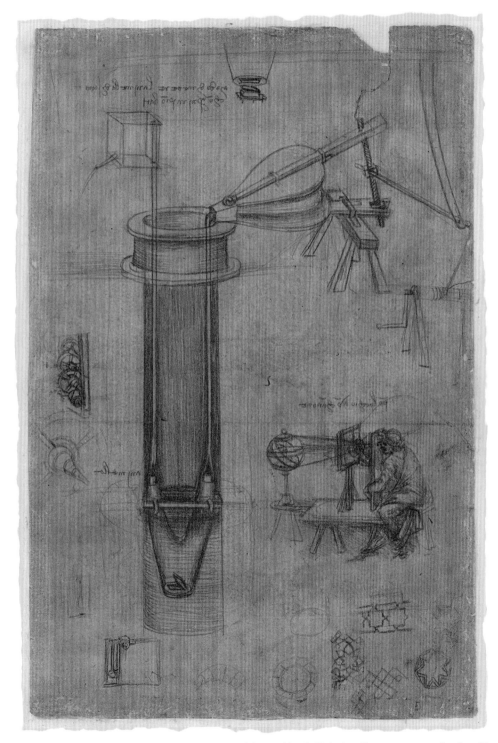

Bellows, Perspectograph with Man Examining Inside: Atlantic Codex, 1478–1519

Pencil on paper, 22 cm x 16 cm (8½ x 6 in)
• Biblioteca Ambrosiana, Milan

A perspectograph is a machine that helps to achieve proper perspective. It enables parts and outlines of objects to be transferred to a painting. Leonardo created this tool with inspiration from Albrecht Dürer, who was one of the earliest artists to think about perspective.

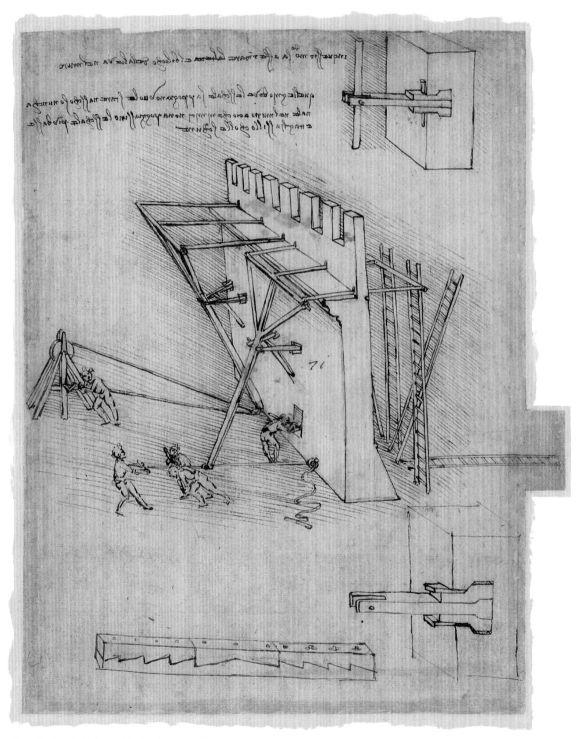

Siege Machine in Defence of Fortification:
Atlantic Codex, 1478–1519
Pencil on paper, 22 cm x 16 cm (8½ x 6 in)
• Biblioteca Ambrosiana, Milan, Italy

This incredible drawing shows a device to repel ladders that would have been erected in order to scale a wall, perhaps during a seige. Michelangelo adapted some of Leonardo's inventions and designs to help with the defence of Florence in 1527.

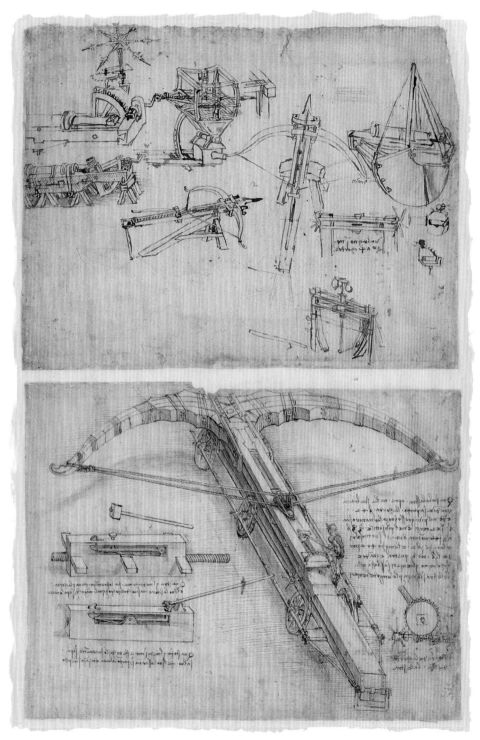

**Spontoon, Crossbows and Bombards:
Atlantic Codex, 1478–1519**
Pencil on paper, 22 cm x 16 cm (8½ x 6 in)
• Biblioteca Ambrosiana, Milan

Leonardo designed this giant crossbow for the defence of Milan. It was part of his inventions to protect via land, sea and air. The size of the man on the shaft who is preparing to release the screw is very small in comparison to the enormous size of this device.

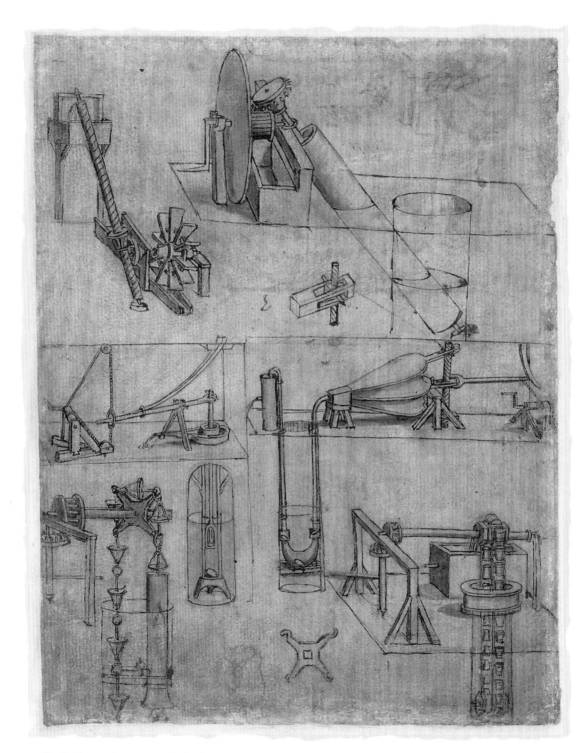

**Six Machines to Lift Water and Details of
Bellows: Atlantic Codex, 1478–1519**
Pencil on paper, 22 cm x 16 cm (8½ x 6 in)
• Biblioteca Ambrosiana, Milan

Leonardo's fertile and febrile mind has here designed no fewer than six
machines for the same task. His designs for lifting equipment and hoists
reveal the workings of the mind of a truly great engineer who is able to be
adaptive and flexible.

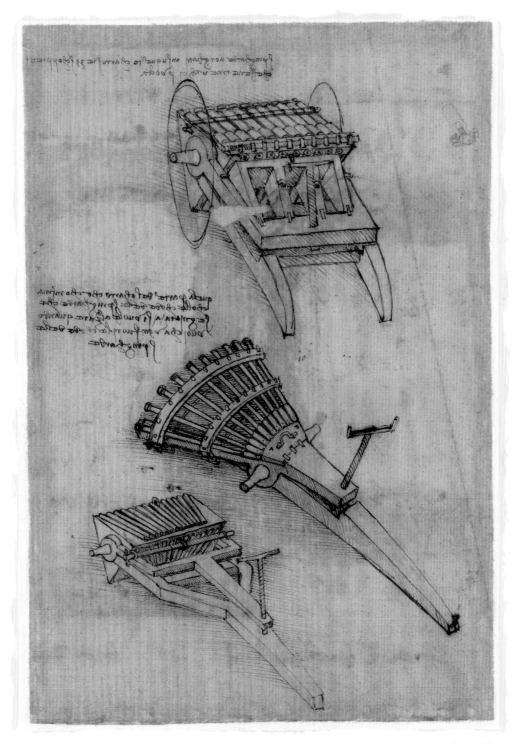

Cart and Weapons: Atlantic Codex, 1478–1519
Pencil on paper, 22 cm x 16 cm (8½ x 6 in)
• Biblioteca Ambrosiana, Milan

The three drawings here show designs for guns with multiple barrels. Leonardo's ingenious mind developed designs for devices that could carry out more than one task at once.

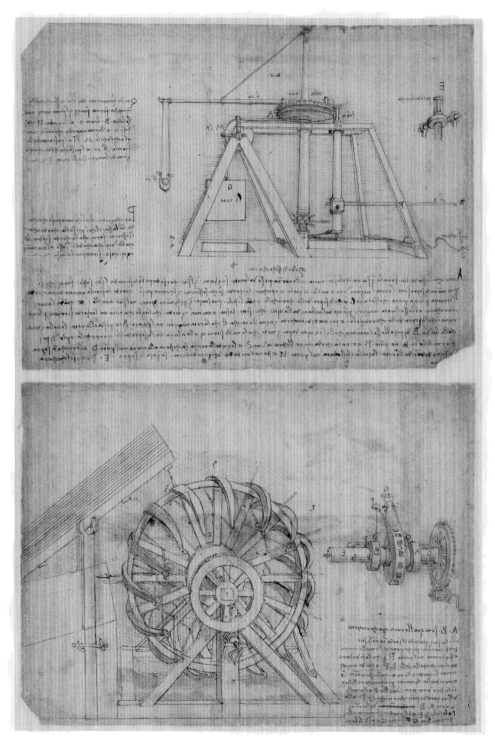

Great Sling Rotating on Horizontal Plane, Great Wheel and Crossbows Device: Atlantic Codex 1478–1519
Pencil on paper, 22 cm x 16 cm (8½ x 6 in)
• Biblioteca Ambrosiana, Milan, Italy

These devices are designed to shower ammunition in a continuous bombardment upon the enemy that allows no time for recovery. Leonardo has drawn close-up sections of the operating mechanisms at the side of each diagram alongside his detailed notes.

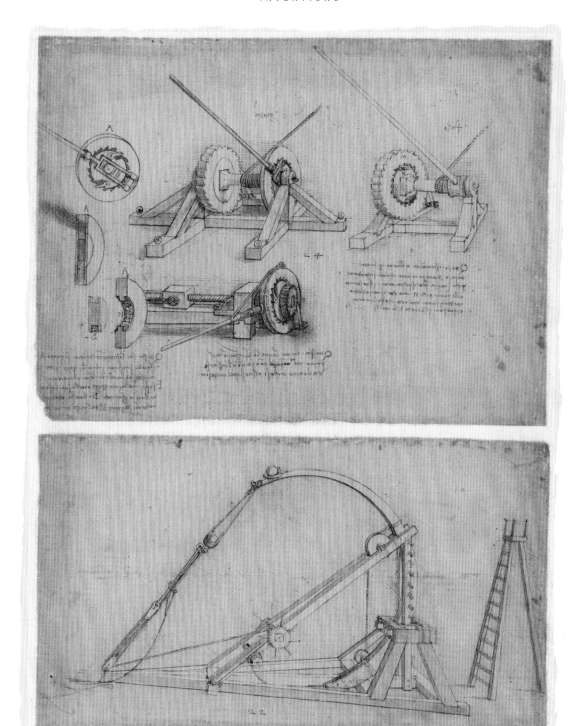

**Winch, Great Spring Catapult and Ladder:
Atlantic Codex, 1478–1519**
Pencil on paper, 22 cm x 16 cm (8½ x 6 in)
• Biblioteca Ambrosiana, Milan

Another design for a giant catapult shows Leonardo's creative mind trying to
come up with the most effective inventions for any situation. The drawings
highlight the intricate details and working parts and mechanisms of these
weapons of destruction.

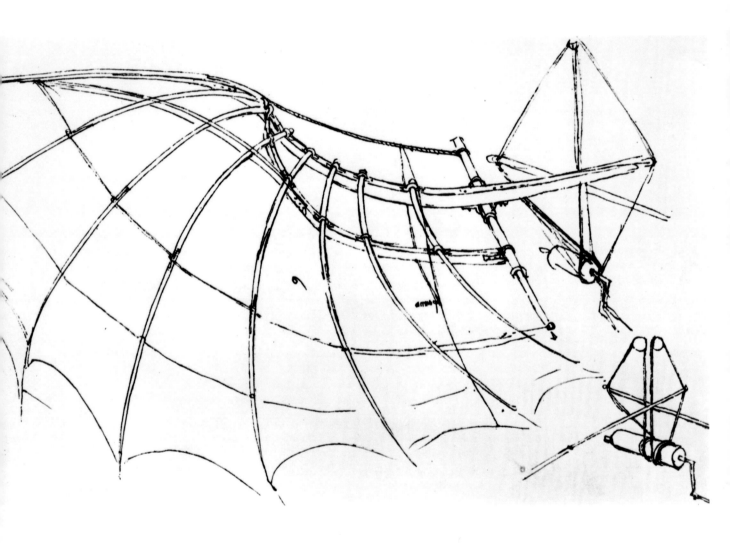

Diagram of a Mechanical Wing, 1488–89
Pen and ink on paper, 28.5 x 20.7 cm (11 x 8 in)
• Bibliothèque de l'Institut de France, Paris

Leonardo wrote many notes about his observations on the flight of birds. The flow and curve of this mechanical wing aims to emulate the flexibility and undulation of a bird's wing.

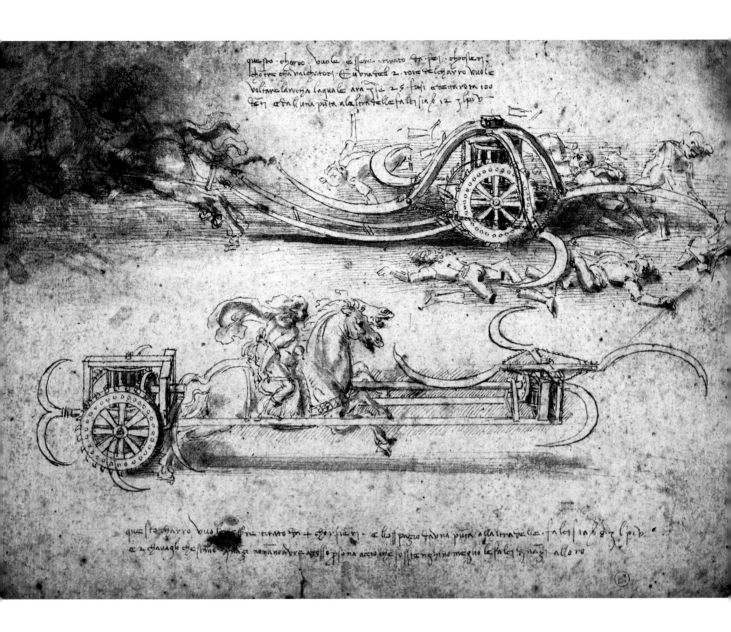

War Machine, c. 1500
Pen and ink on paper, 19.6 x 30.8 cm (7¾ x 12 in)
• Royal Library of Turin, Italy

Both chariots shown here have scythe blades that swing round to kill and maim
the enemy. The galloping horses with streaming tails give an idea of the speed at
which the chariots are travelling.

A Scheme for a Canal to Bypass the Arno, *c.* 1503
Brush and ink over black chalk on paper, 33.5 x 48.2 cm (13 x 19 in)
• Royal Collection Trust, Windsor Castle, London

Leonardo returned later in his career to his earlier idea of constructing a canal to bypass the rapids that prevented the Arno being navigable. The drawing, although vigorous, is uncharacteristically indistinct.

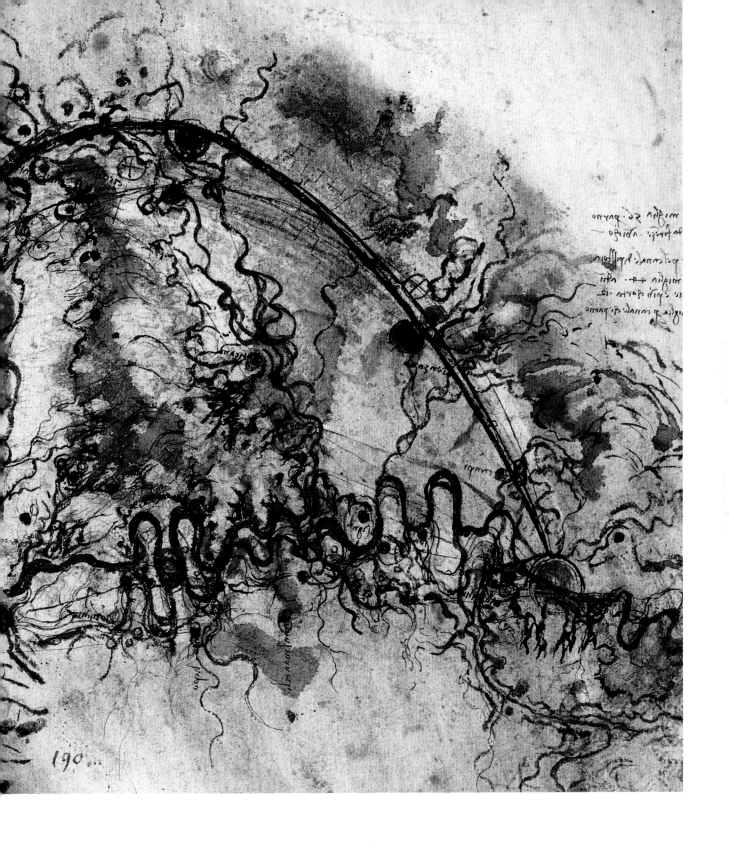

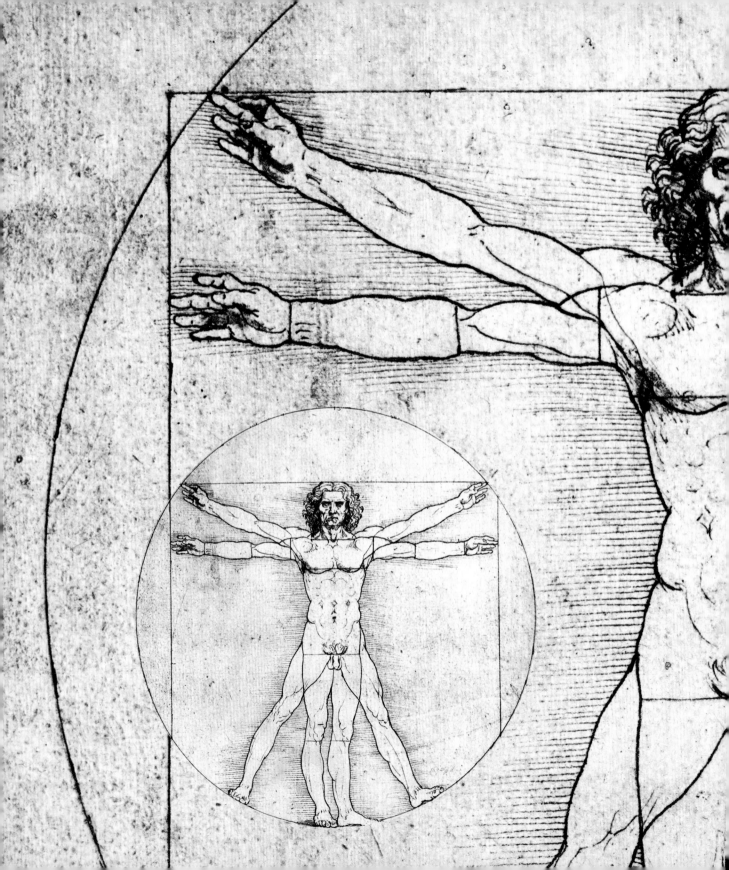

Observations

Leonardo's affinity with the natural world and his skills of observation have given us atmospheric renderings of landscapes and plants, depictions of violent floods and storms, beautiful maps, astronomical studies and intricate geometrical designs.

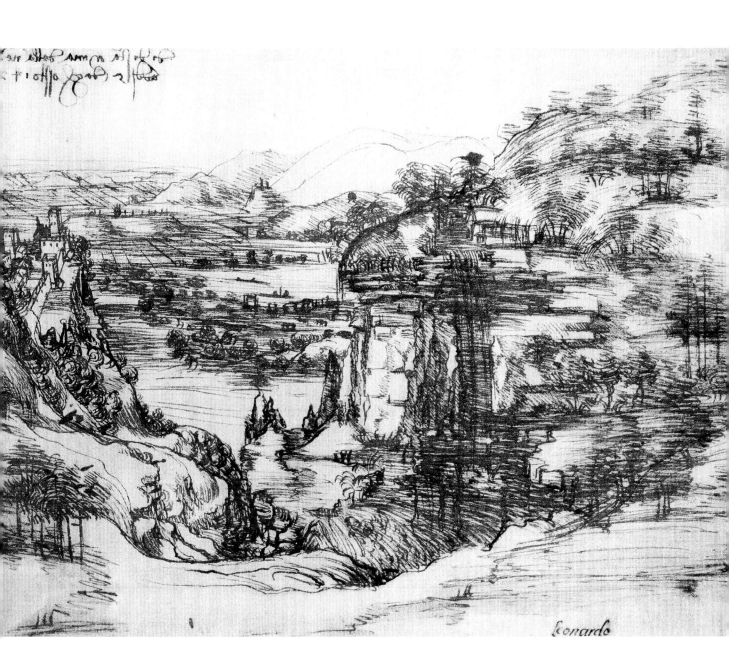

Arno Landscape, 1473
Pen and ink on paper, 19 x 28.5 cm (7½ x 11 in)
• Galleria degli Uffizi, Florence

It has been suggested that this was drawn from the slopes of Montalbano, which is around 10 miles (16 km) from Vinci. The sympathetic rendering of the landscape and the evocative atmosphere create a poetic work of fine draughtsmanship.

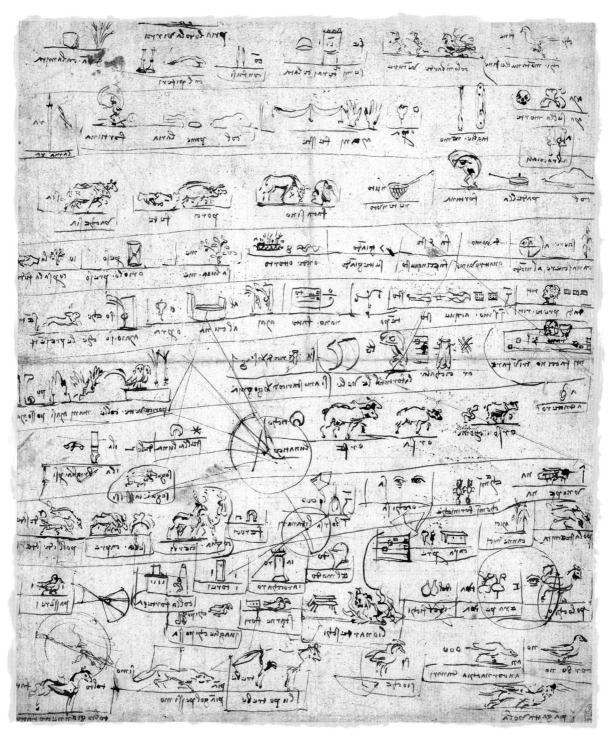

Pictographs Drawn Over Astronomical Studies, *c.* 1487
Pen and ink on paper, 30 x 25.3 cm (12 x 10 in)
• Royal Collection Trust, Windsor Castle, London

A pictograph is a sheet covered with small illustrations usually in rows and accompanied by text alongside the images. Leonardo created numerous pictographs exploring a variety of topics, including some in code.

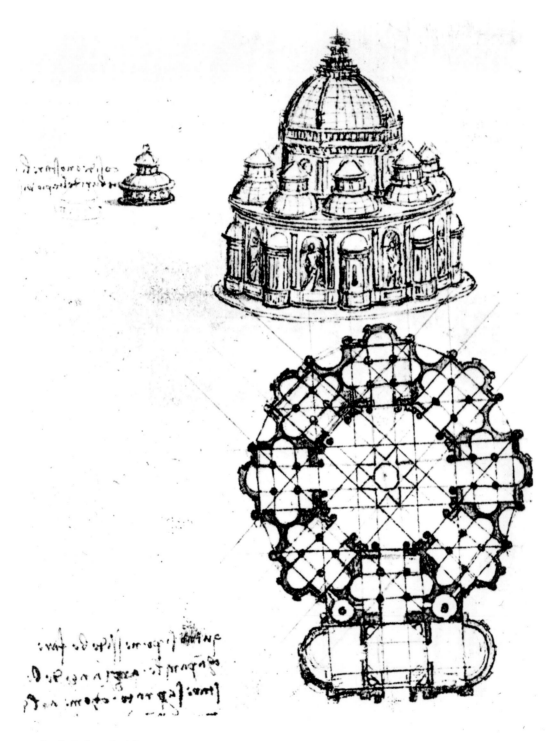

Detail of a Centralized Church, 1488
Pen and ink and wash over black chalk, 24 x 19 cm (9½ x 7½ in)
• Institut de France, Paris

Leonardo is here exploring the use of the perfect forms of the circle and the square, with a view to achieving spiritual harmony in the construction of a church.

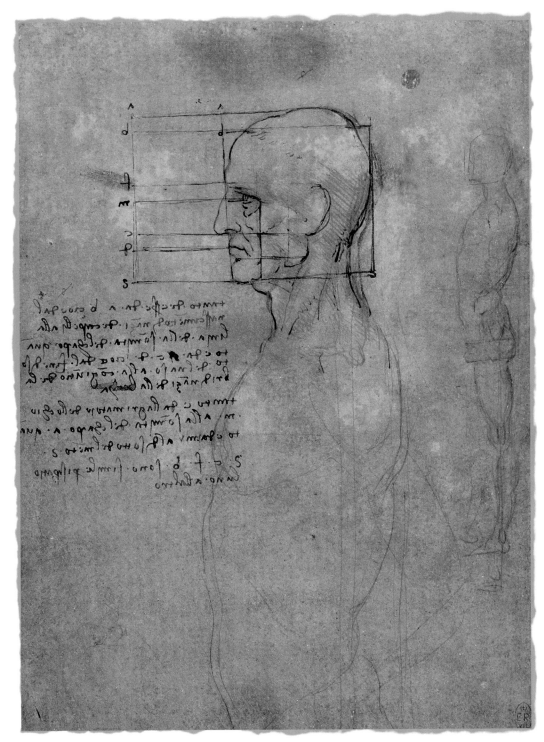

The Proportions of the Head and a Standing Nude, 1490
Pen and ink and metalpoint on paper, 21.3 x 15.3 cm (8½ x 6 in)
• Royal Trust Collection, Windsor Castle, London

Leonardo created many studies of the human body based his studies in mathematics.
Here the profile of a man's face is depicted using squares to achieve balance of proportion.

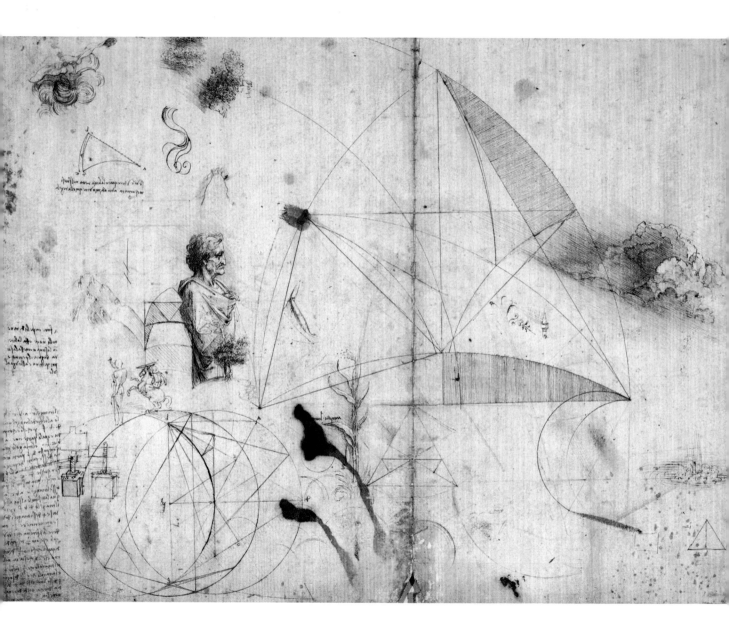

Studies of Geometry, Clouds, Plants, Engineering, 1490
Pen and ink on paper, 32 x 44.6 cm (12½ x 17½ in)
• Royal Collection Trust, Windsor Castle, London

This sheet shows how Leonardo's mind was stimulated by ranging over a wide spectrum of topics. Nature, mathematics, plants and engineering all combined together for Leonardo to create the unity of the absolute and universal world around us.

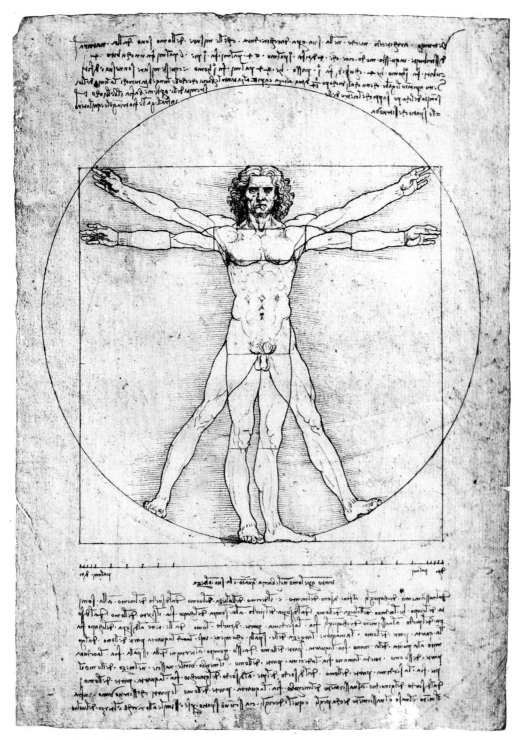

Vitruvian Man, *c.* **1492**
Pen, ink and metalpoint, 34.4 cm × 25.5 cm (13½ x 10 in)
• Private Collection

Leonardo has created a drawing based on the text of the Roman architect Vitruvius
to illustrate the perfect harmony of the human form as it fits into the perfect forms of
the circle and the square.

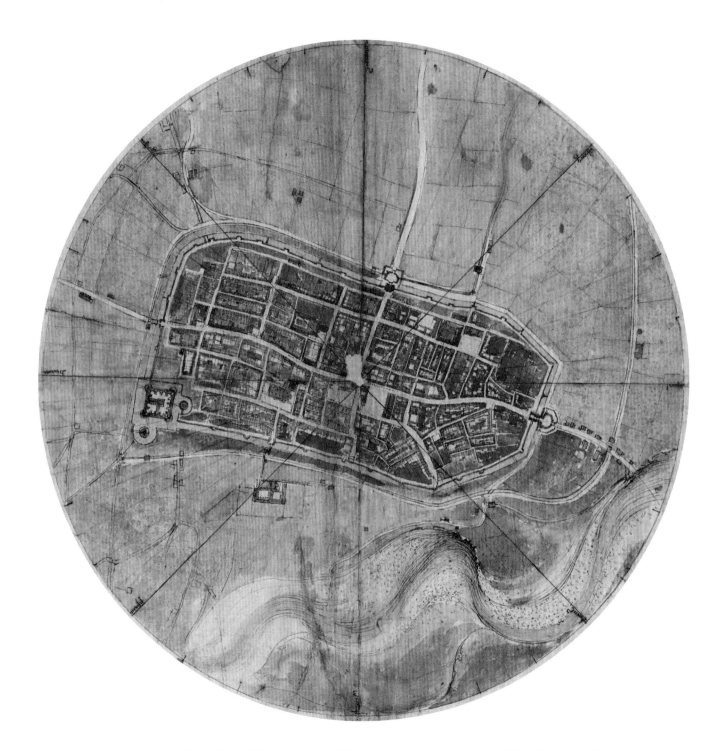

A Plan of Imola, 1502
Pen, ink, wash and chalk on paper, 44 x 60.2 cm (17 x 23½ in)
• Royal Collection Trust, Windsor Castle, London

Leonardo's skills as a cartographer combined with his artistic abilities enabled him to create beautiful maps. This plan was probably made during his service for Cesare Borgia as an architect and engineer.

**Notes and Diagrams on Astronomy and Geometry,
and the Head of a Horse, *c.* 1503**

Pen and ink with black chalk on paper, 19.6 x 30.8 cm (7¾ x 12 in)
• Royal Collection Trust, Windsor Castle, London

Leonardo made many astronomical studies in his time, and his work anticipated
that of Galileo a hundred years later. He imagined an early telescope and also
began to understand something of the solar system that fascinated him greatly.

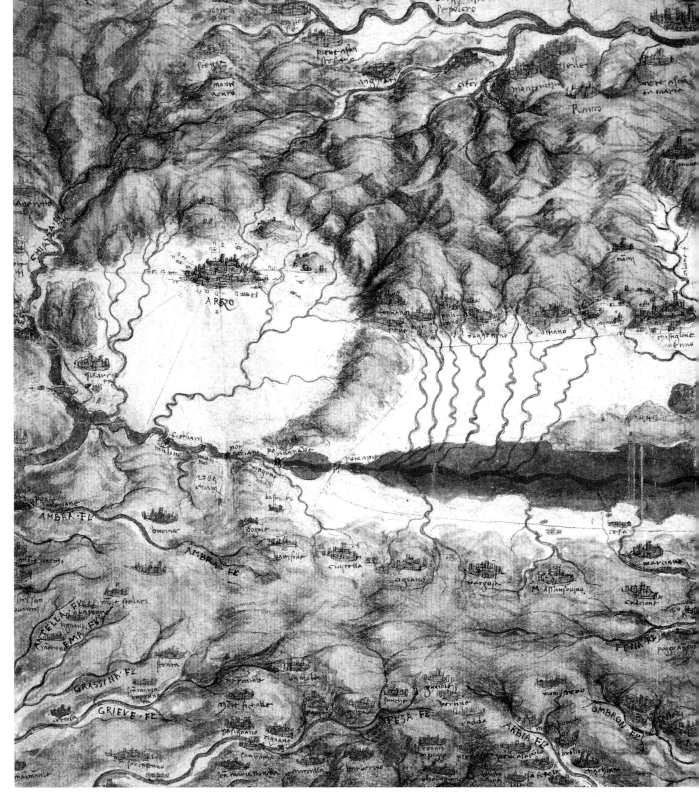

Map of the Valdichiana, 1503–04
Pen, ink, watercolour and chalk, 33.8 x 48.8 cm (13 x 19 in)
• Royal Collection Trust, Windsor Castle, London

A number of towns are marked on this map of an alluvial valley in central Italy, including Perugia and Arezzo. Lake Trasimeno is coloured a delicate shade of blue, which contrasts and yet blends with the brown shading.

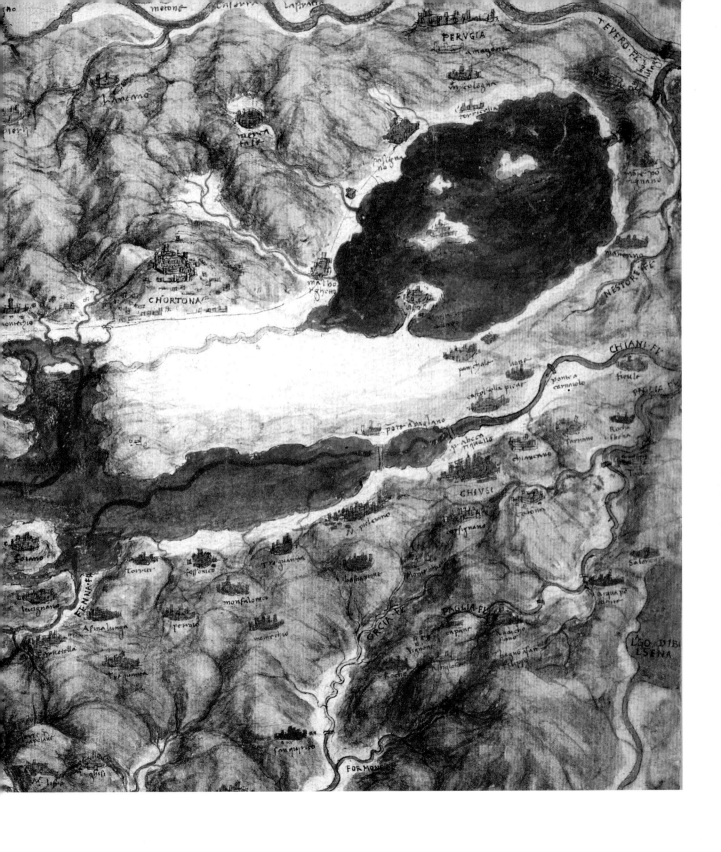

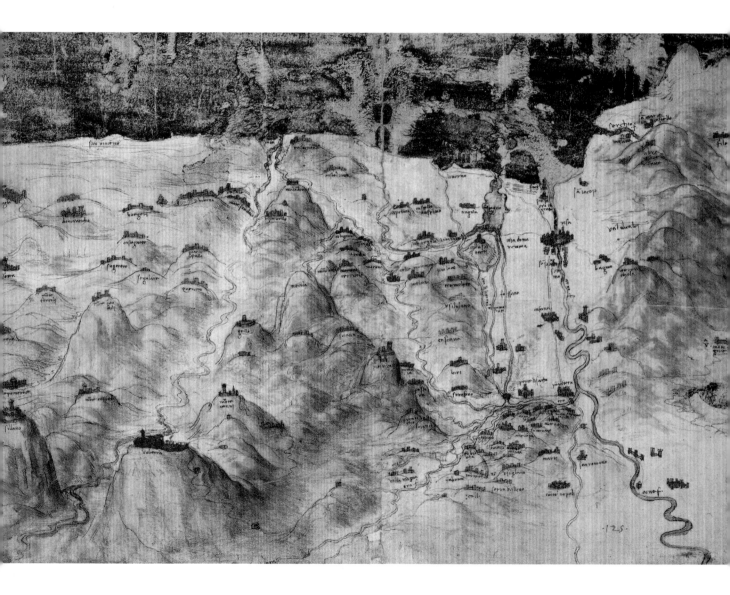

A Bird's-eye Map of Western Tuscany, *c.* 1504
Pen, ink, wash and gouache over chalk, 27.5 x 40 cm (10¾ x 15¾ in)
• Royal Collection Trust, Windsor Castle, London

Leonardo has used lapis for the blue of the sea and rivers, sienna for the towns and sepia wash to create the relief aspects of the hills. Over 60 miles (100 km) of the Tuscan coast is shown.

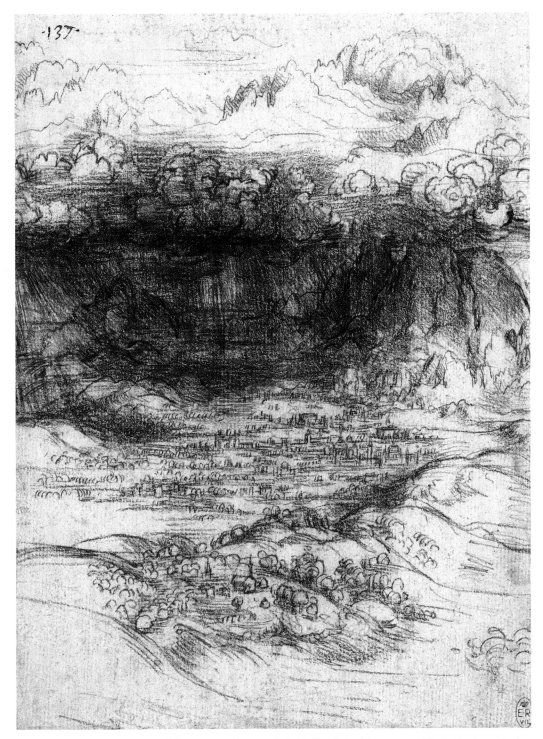

A Storm in an Alpine Valley, *c.* 1508
Red chalk on paper, 19.8 x 15 cm (7¾ x 6 in)
• Royal Collection Trust, Windsor Castle, London

Leonardo was captivated by the effects of downpours and floods. Here heavy clouds release a deluge of water into the valley below, contrasted with the nearby town and countryside, which escape the storm.

Detail of fol. 2R, from the Codex Leicester Showing the Outer Luminosity of the Moon, 1508–12
Pen and ink on paper, 22 cm x 16 cm (8½ x 6 in)
• Science and Technology Museum, Milan

Leonardo's notes reveal that he is studying the light of the moon. He discusses the causes of the moon's luminosity and writes that the moon has an 'ashen surface' (*lumen cinereum*).

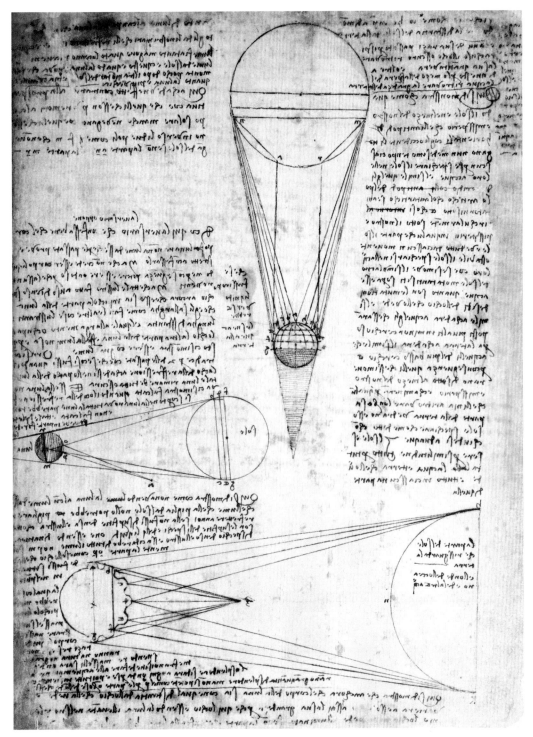

**Studies of the Illumination of the Moon:
Codex Leicester, 1508–12**

Pen and ink on paper, 22 cm x 16 cm (8½ x 6 in)
• Science and Technology Museum, Milan

The very detailed copious notes on this page deal with why the moon is not as bright as
the sun. The drawing at the bottom of the page shows beams from the sun bouncing off
the surface of the moon. The *Codex Leicester* is possibly the most famous collection of
writings by Leonardo.

icofaedron Eleuatum Vacuum

Icosaedron Elevation Vacuum, Illustration from De Divina Proportione by Luca Pacioli, 1509
Lithograph, 29.6 x 21 cm (11½ x 8 in) • Private Collection

Leonardo met the renowned mathematician Luca Pacioli at the Sforza court in Milan. Pacioli became his teacher of mathematics and Leonardo subsequently illustrated Pacioli's book on proportion.

Truncated and Elevated Hexahedron with Open Faces, attributed to Leonardo from De Divina Proportione, 1509
Lithograph, 29.6 x 21 cm (11½ x 8 in) • Biblioteca Ambrosiana Milan

Under Pacioli's tuition Leonardo excelled in geometry. He frequently immersed himself in geometrical games, which were not simply a pastime but an intellectual stimulus and an exploration of the abstract.

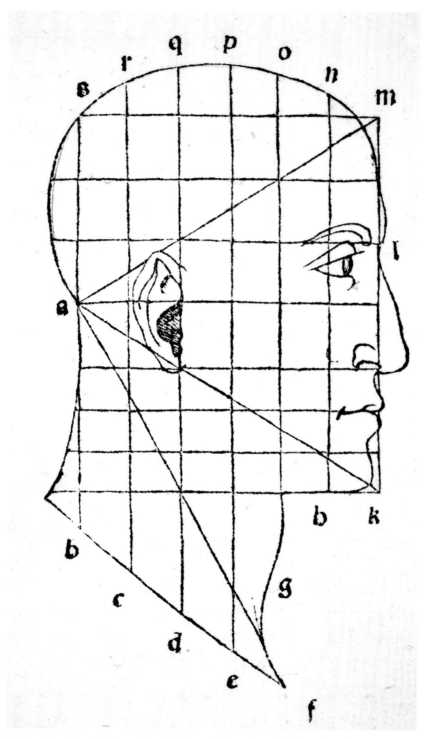

Illustration from De Divina Proportione, 1509
Lithograph, 29.6 x 21 cm (11½ x 8 in) • Private Collection

Leonardo stressed the importance of mathematics in all things, saying:
'He who ignores the supreme precision of mathematics is lost in confusion.'

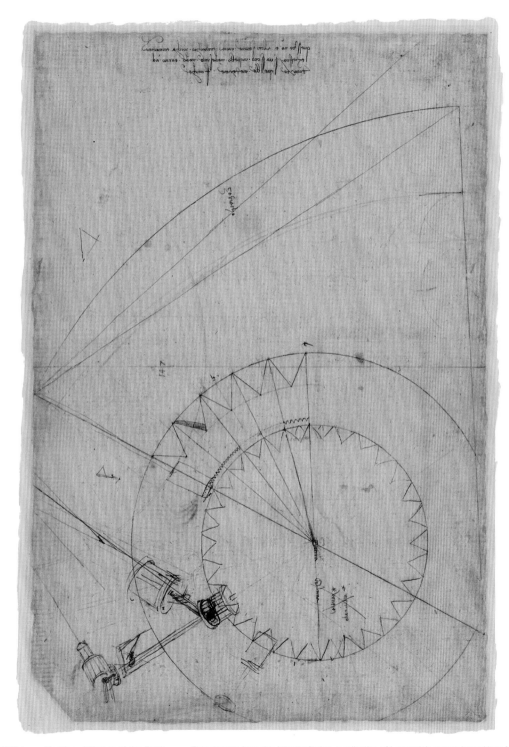

Big Wheel on Which are Mentioned Names of the Earth, Moon, Venus and Mercury and Zodiacal Signs, *c.* **1510**
Pencil on paper, 22 cm x 16 cm (8½ x 6 in) • Biblioteca, Ambrosiana, Milan

This sheet is from the Atlantic Codex, a collection of Leonardo's papers bound into 12 volumes. Because of its size, it was compared to an atlas and so received its name.

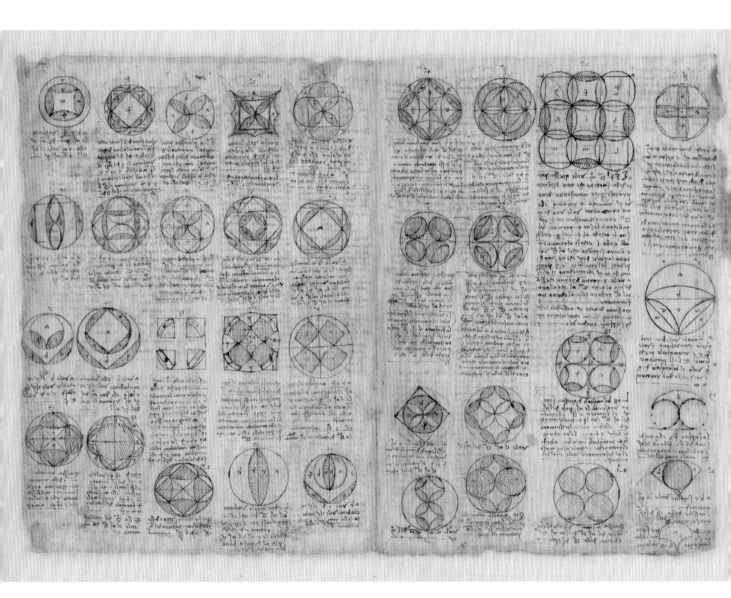

Page from the Atlantic Codex showing Geometrical Drawings, c. 1510
Pen and ink on paper, 22 cm x 16 cm (8½ x 6 in)
• Biblioteca Ambrosiana, Milan

In this drawing Leonardo is dealing with the challenge of 'squaring the triangle', which was closely linked to his work on the golden ratio. He was also studying here the transformation of curved surfaces to surfaces bounded by straight lines, and vice versa.

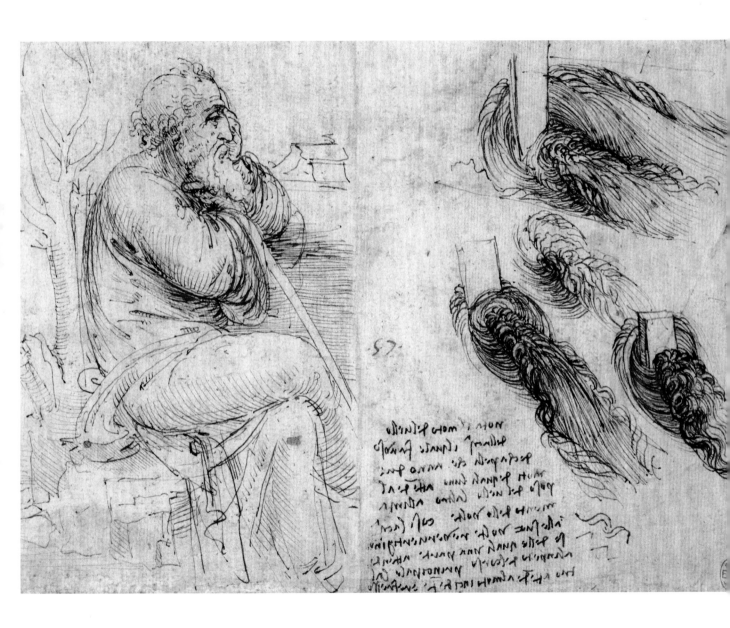

**A Seated Man and Studies and Notes
on the Movement of Water,** *c.* **1510**
Pen and ink on paper, 15.4 x 21.7 cm (6½ x 8½ in)
• Royal Collection Trust, Windsor Castle, London

One of Leonardo's favourite topics, the movement of water, is again dealt with here.
He links this study with applications to his artistic work by comparing the swirling of
water to braided hair.

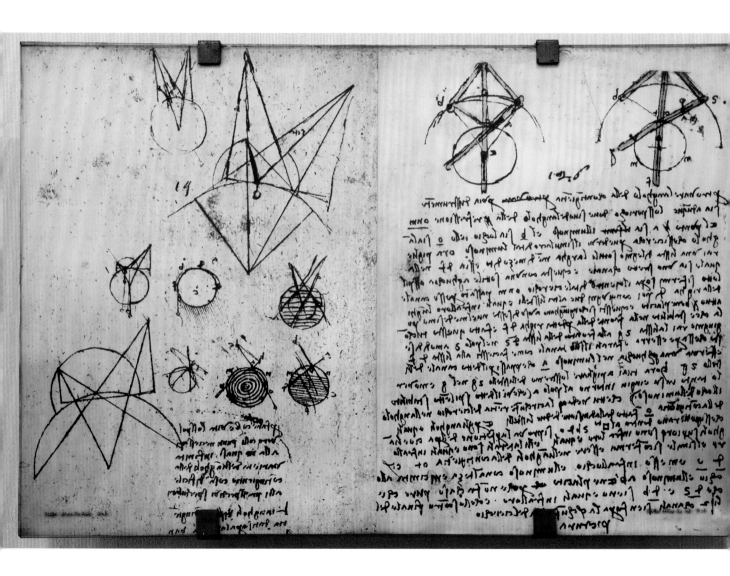

Alhazen's Problem from Atlantic Codex, *c*. 1510
Pen and ink on paper, 22 cm x 16 cm (8½ x 6 in)
• Science and Technology Museum, Milan

Alhazen was a tenth-century Arab polymath who specialized particularly in the fields of optics, astronomy and mathematics. Here Leonardo discusses a problem posed by Alhazen regarding lines drawn in the plane of a circle.

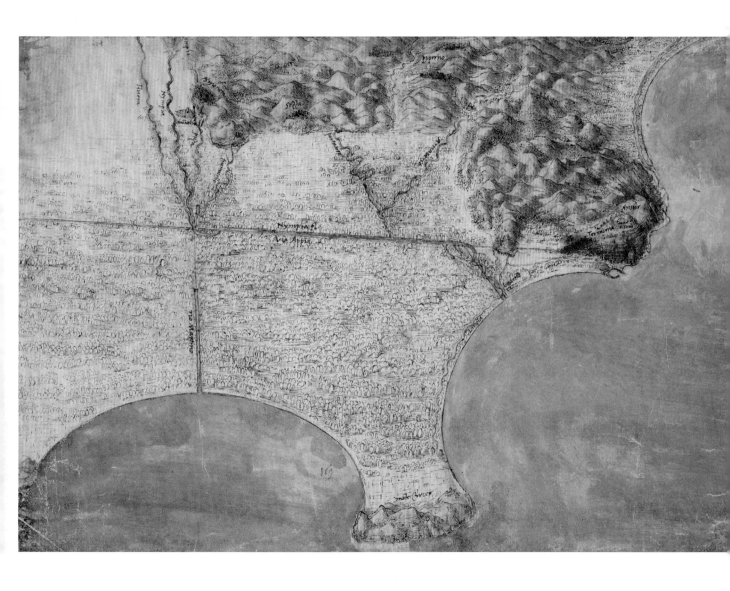

A Map of the Pontine Marshes, 1515
Pen and ink with wash, 27.7 x 40 cm (11 x 15 in)
• Royal Collection Trust, Windsor Castle, London

Leonardo's map-making skills created a synthesis of the knowledge of the time, marrying information about terrain to aesthetics and so creating a 'geographic art'. In this study he provides an aerial view showing marshlands, coastline and towns.

Indexes

General Index

Page numbers in *italics*
refer to illustrations.

Masterpieces of Art

FLAME TREE PUBLISHING

A new series of carefully curated print and digital books covering the world's greatest art, artists and art movements.

If you enjoyed this book, please sign up for updates, information and offers on further titles in this series at

blog.flametreepublishing.com/art-of-fine-gifts/